Copy-1

W9-DIJ-149

The Art Institute of Chicago

MUSEUM STUDIES

VOLUME 15, NO. 2

WITHDRAWN

The Art Institute of Chicago Museum Studies
VOLUME 15, NO. 2

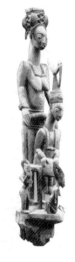

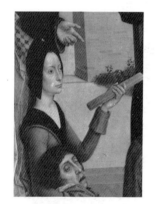

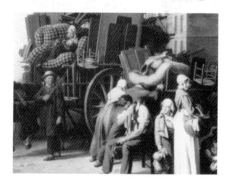

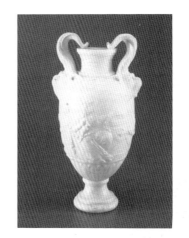

Preface

In this issue of *Museum Studies*, we provide our readers with the opportunity to explore the broad range of the Art Institute's collections: to learn about works from different departments, periods, and geographic locations. We are featuring articles on four artists represented in our departments of European painting and sculpture. In addition, we offer a study of the work of an early twentieth-century African sculptor. Despite their diversity, the works covered in these pages do have one common characteristic: in differing ways, they all demonstrate artistic alternatives either to previous artistic practice, or to prevailing notions about their cultural milieu.

The Art Institute is renowned for its collection of French Impressionist and Post-Impressionist paintings, some of which have been featured in previous issues of *Museum Studies*. The two articles on French nineteenth-century artists probe new territory by examining works produced prior to or outside the more celebrated movements of the last century. Jean Léon Gérôme's achievements have been overshadowed by those of his now-popular, revolutionary counterparts, but, in his day, he was one of the most famous artists in France. Jack Perry Brown, Director of the Ryerson and Burnham Libraries, surveys our Gérôme holdings, which include both paintings and sculptures depicting a variety of subjects, from portraiture to historical and allegorical themes. Gérôme was a constant prizewinner in the official Salon exhibition; his erudite subject matter, in contrast to the Impressionists' scenes of contemporary leisure, reflect the values of France's art establishment. The Art Institute's holdings of his work demonstrate the wide-ranging interests, from classical antiquity to recent history, that absorbed the artist and inspired his work.

The French nineteenth-century painter Louis Léopold Boilly also exhibited at the Salon, but his subjects were not the grand Neoclassical evocations of history and allegory, nor Romanticism's view into exotic worlds. Boilly created genre paintings, works traditionally thought to depict everyday scenes. In an essay devoted to Boilly's *Moving House*, now at the Art Institute, Susan Siegfried, of the Getty Art History Information Program, examines Boilly's vision of the world around him. In this image of the annual relocation of Paris's transient population, she discovers a number of features that contradict its traditional interpretation as a straightforward genre painting. Far from being a neutral observation of contemporary society, Boilly's work reflects the artist's strong middle-class biases and values.

From the nineteenth century, we move back in time to examine two earlier works, a painting and a sculpture, which represent a new approach to an

established iconographic or formal type. Dieric Bouts's moving painting of the *Sorrowing Madonna*, a recent acquisition, is one of the most beautiful works in the collection of the Department of European Painting. Discussed by Curator Martha Wolff, this image of the mourning mother of Christ represents the left side of a two-paneled work, or diptych, whose other half, now lost, depicted the Christ Crowned with Thorns. In the fifteenth century, this type of private devotional image enhanced the worshipper's religious meditation by focusing his or her attention on the events of Christ's life and Passion. As Wolff demonstrates, the Art Institute's work is noteworthy both for its innovative approach to this iconographic type, and its status as the prototype for a series of replicas produced by Bouts's followers.

In 1987, the Art Institute acquired an exquisite marble vase by the French Neoclassical sculptor Clodion. As he is best known for his small terracotta figures, this work marks a departure for him in both medium and format. Anne Poulet of the Museum of Fine Arts, Boston, examines Clodion's other innovations, particularly his use of antique, Renaissance, and Baroque prototypes, which he researched during his stay in Rome as a student and young artist. By combining these diverse sources, this extraordinary artist created a new genre of sculpture, whose popularity was attested to by the numerous commissions for his workshop and the many replicas that followed the original work.

The Yoruba people of southwestern Nigeria possess an ancient cultural tradition dating back to the fifth century B.C. The Art Institute is fortunate to have in its collection of African art an outstanding example of Yoruba figural sculpture, a supporting post from the veranda of the king's palace at Ikere. Unlike the majority of African works in museum collections, which come without definite knowledge of their maker, the veranda post is attributed to a renowned artist, Olowe of Ise. In his article on this masterpiece, Amherst College anthropologist John Pemberton III explores its iconography, which embodies the Yoruba concept of sacred kingship and the aesthetic qualities imparted to it by its creator.

RACHEL A. DRESSLER
Editor

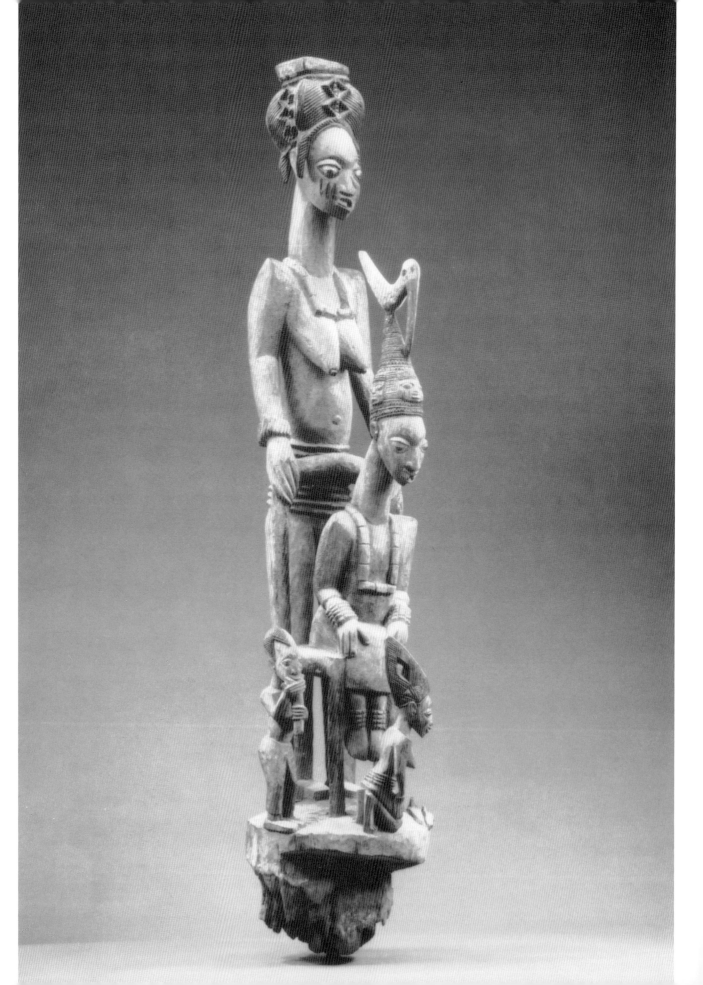

Art and Rituals for Yoruba Sacred Kings

JOHN PEMBERTON III,
Amherst College, Amherst, Massachusetts

THE CARVING depicting a king and his consort in the collection of the Art Institute of Chicago is a masterpiece in the history of West African art (cover and fig. 1). It is one of three veranda posts carved by Olowe of Ise for the palace at Ikere, a small Yoruba town in the southern Ekiti area of southwestern Nigeria. The sculptures were created for the veranda of an inner courtyard where the *ogoga*, king of Ikere, received visitors. Originally, the Art Institute post occupied the center position in the ensemble. The post to its right depicted an equestrian figure, and is now in the collection of the New Orleans Museum of Art. That on the left exhibited a queen presenting her twin daughters to the king. It is in the collection of the Memorial Art Gallery, Rochester, New York. Created for a royal architectural context, these images, and the Chicago work in particular, reveal the Yoruba understanding of the foundation and extent of the king's power.

The twelve to fifteen million Yoruba people of southwestern Nigeria, the Republic of Benin (formerly Dahomey), and Togo are the heirs to one of the oldest cultural traditions in West Africa. Archeological and linguistic evidence indicates that the Yoruba have lived in their present habitat from at least the fifth century B.C. The development of regional dialects that distinguish the Yoruba subgroups and the process of urbanization, which developed into a social system unique among sub-Saharan African peoples, took place during the first millenium A.D. By the ninth century, the ancient city of Ile-Ife was thriving; and in the next five centuries, Ife artists would create terracotta and bronze sculptures that are now among Africa's finest artistic

FIGURE 1. Olowe (Nigerian, Yoruba People, Ise; act. c. 1860–1938). Veranda post from the palace at Ikere, c. 1910–14. Wood and paint; h. 154.9 cm. The Art Institute of Chicago (1984.550). Like much of the art of Ife, a subgroup of the Yoruba nation, this work was produced for a royal context. This image of a king and his consort, from an ensemble of posts sculpted for a palace courtyard, expresses the Yoruba concept of sacred kingship by the size and position of each of its figures.

97

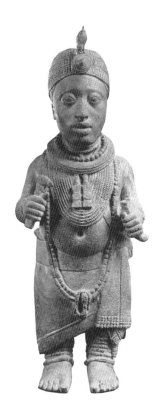

treasures (see fig. 2). In addition, throughout Yorubaland, and especially in the palaces of lesser kings, the more perishable medium of wood was the principal material of artistic expression.

Both Yoruba myth and oral history refer to Oduduwa as the first king and founder of the Yoruba people. Some myths portray him as the agent of creation and assert that the place of creation was Ile-Ife, which subsequently became the site of Oduduwa's throne (see fig. 3). Oral history and archeological studies, however, suggest that he was the leader of an invading tribe identified in the myths as from "the east," who conquered the indigenes of the Ife area prior to the ninth century. While it is increasingly apparent that the socio-political model of a town presided over by a paramount chief or sacred king, an *oba*, was well established in Ife by the ninth century and

FIGURE 2. Nigeria, Yoruba People (Ife, Ita Yemoo). Figure of an ooni or king, early 14th/early 15th century. Zinc brass; h. 47 cm. Ife, Museum of Ife Antiquities. Photo: By Dirk Bakker, in Ekpo Eyo and Frank Willet, *Treasures of Ancient Nigeria* (New York, 1980), p. 96. While Ife art is characterized by a high degree of naturalism, its artists have not reproduced the external appearance of nature. In this arresting piece, the artist emphasized certain features of the figure, such as the head, to convey the subject's essential nature and inner authority.

FIGURE 3. Map of Yorubaland. Photo: William Fagg and John Pemberton III, *Yoruba Sculpture of West Africa* (New York, 1982). The Yoruba people are divided into approximately twenty subgroups, distinguished by a variety of customs and institutions, and constituting autonomous kingdoms. On the map, the names of these subgroups appear in upper case letters.

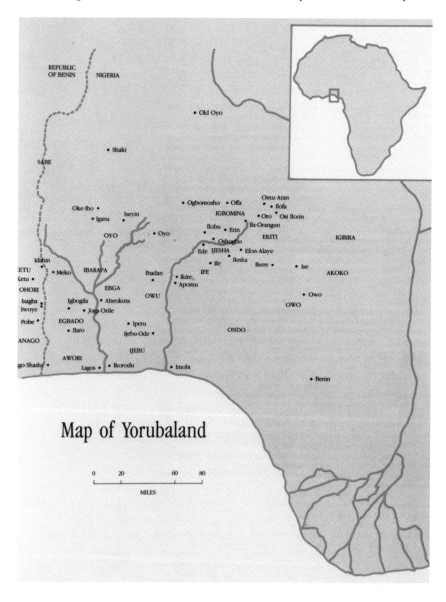

Map of Yorubaland

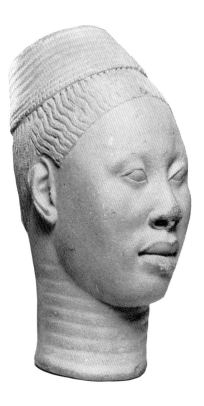

FIGURE 4. Nigeria, Yoruba People (Ife, *ooni's* palace). Head said to represent the usurper Lajuwa from the *ooni's* palace, Ife, 12th/15th century. Terracotta; h. 32.5 cm. Ife, Museum of Ife Antiquities. Photo: By Dirk Bakker, in Eyo and Willet (fig. 2), p. 103. Ife artists created superb works of art in both bronze and terracotta. Their technique of terracotta modeling may have been rooted in the traditions of an earlier people, the Nok culture of c. 500 B.C. to 200 A.D. The Ife themselves are credited with developing the "lost wax" method of bronze casting, which they employed with consummate skill as early as the twelfth century.

present among other Yoruba subgroups, the followers of Oduduwa developed the urban tradition and enhanced the role of the king over the next four centuries. In later years, persons who sought to establish their political legitimacy, even when they too were from immigrant groups, were required to trace their descent from Oduduwa. They were known as "the sons of Oduduwa," or *omo Oduduwa*, whose father had given them their beaded crowns, symbols of their sacred authority, although some accounts suggest that, when the king was old and blind, the sons stole their fathers' crowns and established their own kingdoms.

It is not known exactly when what we term Ife art began to develop. The Africanist Frank Willett has established radiocarbon dates for the earliest art ranging between the eleventh and the fifteenth centuries.[1] Superbly crafted bronzes were discovered in 1938, during the digging of the foundation for a house in a compound not more than 200 yards from the palace of the *ooni*, the king, of Ife. They were located at a depth of no more than two feet. Subsequent discoveries recovered terracotta objects, among which were heads (see fig. 4), as well as figures. These artifacts attest to a highly developed artistic tradition among the Yoruba by the twelfth century.

The location of the excavated objects suggests the royal nature of their function. Since most of the artifacts have been found beneath the compounds of Ife's royal lineages, or in sacred groves, it would appear that Ife art was the product of court sponsorship. Consequently, the early date of these items indicates the antiquity of both the Yoruba concept of kingship and the office of the *oba*.

In contrast to the art of many other African peoples, the Ife bronzes and terracottas are characterized by a high degree of naturalism in the depiction of the subject, usually the human figure (see figs. 2, 4). To speak of the naturalism of Ife art is not to suggest portraiture in the sense of copying nature. On the contrary, Yoruba art is conceptual. That is, the artist concentrates on what he knows and believes about his subject rather than on what he can see. Some art historians have used the term "idealized naturalism" with reference to the Ife bronze and terracotta heads. While physical beauty, or *ewa*, as well as elegance of adornment, characterizes many Ife sculptures, Rowland Abiodun has observed that one should view Ife sculptures and all Yoruba figural sculpture in terms of the Yoruba proverb "Character is beauty" (*Iwa l'wa*). That is, the Ife sculptures, while perhaps portraying

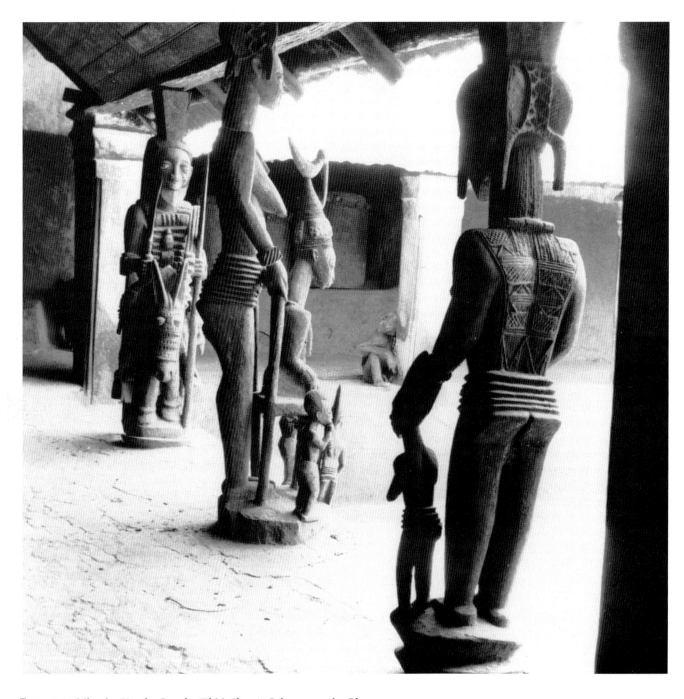

FIGURE 5. Nigeria, Yoruba People (Ekiti, Ikere). Palace veranda. Photo: William Fagg. This veranda faced the inner courtyard of the palace and was the place where the *ogoga*, king of Ikere, received visitors. In the photo, the Art Institute's post occupies the center position. It is flanked by the figure of a horseman with sword and spear (see fig. 8) and a woman with twins (see fig. 6).

FIGURE 6. Olowe (Nigerian, Yoruba People, Ise; act. c. 1860–1938). Veranda post from the palace at Ikere, c. 1910–14. Wood and paint; h. 139.7 cm. Rochester, New York, Memorial Art Gallery. Photo: William Fagg. In Yoruban philosophy, a woman's *ase*, or inner strength, is associated with her reproductive power. It is this concept, expressed by the maternal image of a mother with two twins, that Olowe presented in this depiction of a queen.

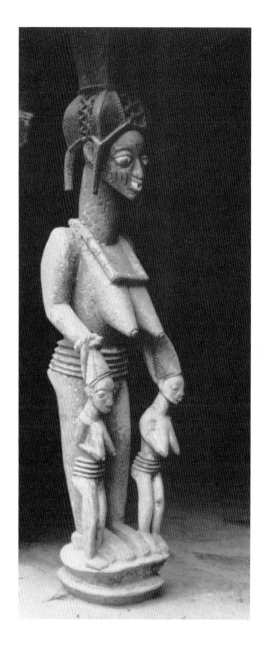

certain physical characteristics of particular persons, are statements about the "essential nature" (*iwa*) and "inner authority" (*ase*) of the persons memorialized.[2] In Yoruba thought concerning the self, a person's *iwa* is linked to his or her personal destiny, or *ori*. The word *ori* also means "head." Hence, Yoruba artists took advantage of the dual reference of meaning when they emphasized the head, often assigning a third of the sculptural form to this portion of the figure (see fig. 2).

In its figural style, iconography, and the circumstances of its production, the Art Institute sculpture belongs to the court milieu that has informed the art of the Yoruba for centuries. The Africanist William Fagg has referred to the artist responsible for its creation "as the best and most original Yoruba carver" of the twentieth century.[3] Olowe was born in the Ekiti town of Efon-Alaye, one of the great centers of Yoruba carving at the turn of the century. At an early age, he moved to Ise, a village to the southeast (see fig. 3). There, according to Fagg, Olowe "became an *emese* or messenger of the *arinjale*, or king of Ise, and for many years, until his death in 1938, he had great fame in the area as a carver of architectural sculptures such as doors and veranda posts."[4]

The ogoga, commissioned Olowe, no doubt with the Arinjale's approval, to create three veranda posts, including the one now in Chicago, and a door similar to those that Olowe had executed for the palace at Ise. The sculptures were for the veranda of the outer courtyard. There were two doors at the rear of the veranda. A small door led directly to the palace of the ogoga. A larger door, carved by Olowe, led to an area called Imorun, which contained the shrine for the king's head, or *ori*. We are indeed fortunate to have the photographs Fagg took on his visit to the Ekiti region in 1958–59 (see fig. 5).

All of the veranda posts give the impression of height and power. The erect posture of the queen with her twins (fig. 6), as she balances the veranda support on her head, as well as the descending braids of hair which frame her face, the elongation of her neck, the strength of her shoulders and length of her pendulous breasts, and the slight size and slender bodies of the children, who raise their breasts in a gesture of greeting to their father, all accentuate the vertical line of the sculpture and create an impression of height far in excess of its 55 inches. However, the strong verticality is bisected at several points by the slightly curved diagonal line created by the neck beads and breasts, as well as by the queen's lower arms and hands, which rest gently on the heads of the twins, and in the angle of the lower portion of the buttocks. The rhythm in the series of diagonal lines provides a subtle counterpoint to

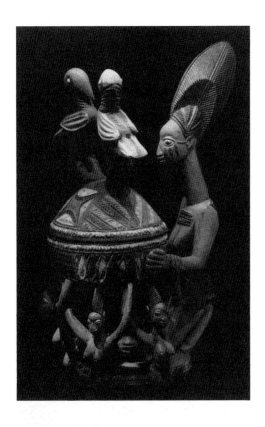

FIGURE 7. Olowe. Female figure with bowl. Wood and paint; h. 54 cm. Ruth and Paul Tishman Collection. Photo: Jerry L. Thompson in Susan Vogel, ed., *For Spirits and Kings: African Art from the Paul and Ruth Tishman Collection* (New York, 1981), p. 104.

the vertical axis and is echoed again in the figures of the twins. As we shall see, Olowe's particular stylization suggests the artist's interest in geometric shapes and designs when he addressed the problem of representation of the human body, while nevertheless maintaining a high degree of naturalism in his sculpted figures.

The skill of Olowe as a sculptor is seen in a comparison of the veranda post with his representation of a kneeling female figure with bowl (fig. 7). In this work, Olowe balanced the angle and length of the coiffure with that of the neck, thereby enhancing the importance of the face. The angle of the hair style is repeated again in the folded position of the legs and feet, thus, in some measure, framing the figure's action of holding an offering bowl. This gesture recurs in the circle of kneeling female *arugba* figures who hold aloft the great bowl with their slender arms. *Arugba* means bowl carrier and refers to a female devotee who carries the offering bowl on her head in rites during the annual festival for an *orisa*, a god of the Yoruba pantheon. Carvers in Ekiti and adjacent Igbomina towns often depicted kneeling or seated *arugba* figures in their shrine sculptures for *orisa* Sango, the patron deity of the kings of the Oyo Empire, and for *orisa* Osun, deity of medicinal waters. An alternative type for shrine sculptures was a kneeling female figure holding an offering bowl in front of her. Olowe uses both versions in his splendid carving, linking the separate actions through the gesture of two of the smaller figures grasping the wrists of the larger figure.

Olowe was a master of composition; he had what in Yoruba is called *oju-ona*, or design consciousness. This term refers to the artist's sensitivity to form and to the relationship of form to subject. The subject of the Memorial Art Gallery's veranda post is not merely a woman with twins, but *ase*, or inner power, the dignity and strength of a woman who is also a queen. The woman kneeling with the bowl also represents female *ase*, her power of reproduction, which Olowe associated with the gesture of offering, an action by which the world is sustained.

In the artistry of Olowe, surface ornamentation complements formal properties. The scale and boldness of Olowe's figures permitted him to carve elaborate hair styles, to incise intricate decorative patterning on the bodies, and to depict multiple strands of waist beads without diverting attention from the sculptural subject. This is also true of the equestrian figure, now in the New Orleans Museum of Art, which stood on the veranda at Ikere juxtaposed with the queen with twins (see figs. 5, 8). Once again, Olowe's design consciousness can be observed in the overall pyramidal shape of the sculpture, a large base tapering toward the rider's face and supporting timber. When viewed from the front, the "V" created by the horse's ears and the triangular shape repeated in the pointed beard of the rider are subtle inversions of the overall form of the sculpture. In addition, the artist framed the rider's face with the slender, parallel lines of sword and spear. These geo-

metrical shapes have as their counterpoint the detailed and careful carving of the bridle on the horse and of the garment of the hunter-warrior, which conveys the integral relationship of horse and rider.

As one approached the veranda, it was the side view of the equestrian figure one saw (see fig. 8). Again Olowe's genius is apparent in the way in which, despite all the attention he paid to detail, it is the face of the hunter-warrior that catches the viewer's attention. This is due in part to the boldness of the facial features—the large bulging eyes and exposed teeth—but also to the way in which the short, sharp line of the beard, which moves up to the ear, has its counterpart in the long, sweeping line of the hunter's coiffure. The line extends from the brow over the head and down the back of the neck, thereby enlarging the head and framing the face.

In the equestrian figure, as in the queen with twins, we are presented with an image that conveys *ase* and *iwa*. The *ase* of a woman is expressed in the *ewa*, of a mature woman, whose body is adorned with beads and whose head is elaborately styled. Yet, despite its external visualization, a woman's *ase* is an inner power, a covert strength manifest in the blood she sheds in giving birth. By contrast, man's power is overt. It lies in his physical strength, his prowess as a horseman and as one whose sword and spear shed the blood of others. Hence, Olowe's artistry may be described not only by the concept of *oju-ona* but as possessing *oju-inu*, an inner eye, the insight or discernment of one who requires the viewer to pause, to be attentive, and to become aware of the expressive forms by which images are created that shape our experience and understanding.

The central veranda post, now in the Art Institute, is the most important and astonishing of the ensemble (see figs. 1, 5, 9). It was the focal point of attention, for the queen with twins and the equestrian figure faced the seated king and his senior wife. What appears to us as extraordinary is the monumental size of the queen and the diminutive size of her royal spouse, whose head tilts slightly forward as he looks upon the kneeling female figure before him, a point to which we will return later.

Once again, Olowe's skill as an artist reveals itself in his sensitivity to composition, for despite the openness of the sculpture of the king and queen, the clear separation of the figures, the sculptor succeeded in relating them to one another in a hieratic format. At the base, a woman kneels before the king, her hands resting on her thighs. To the king's right, a palace servant, whose head is shaved on the left side, plays a flute, announcing the king's presence. As we can see from Fagg's photographs, another palace servant (now missing) carried the royal fan. The king sits upon a chair, the back of which frames his body. His manner is composed and somewhat distant from the activity that surrounds him. He wears the great conical, beaded crown, or *adenla*, of a Yoruba king. A bird is perched at the top, its beak curving halfway down the front of the crown. Behind the king is the tall, slender figure of the queen, whose breasts frame the king's crown and whose neck and head tower above it.

The face of the queen turns slightly to her left, as does the body of the king. The figures are royal, but not rigid. As in the sculpture of the queen with her twins, in this work a diagonal line intersects the vertical, relating the royal couple to one another. For example, the line of the queen's jaw is

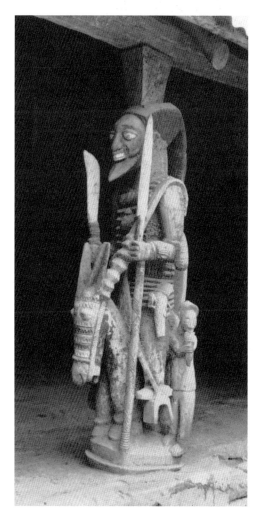

FIGURE 8. Olowe. Veranda post from the palace at Ikere. Wood and paint; h. 141 cm. New Orleans Museum of Art. Photo: William Fagg. In contrast with the *ase* of females, that of the male is expressed in terms of his physical strength, his prowess as a horseman and fighter. The sword and spear, the weapons he uses in battle, symbolize this mounted horseman's *ase*.

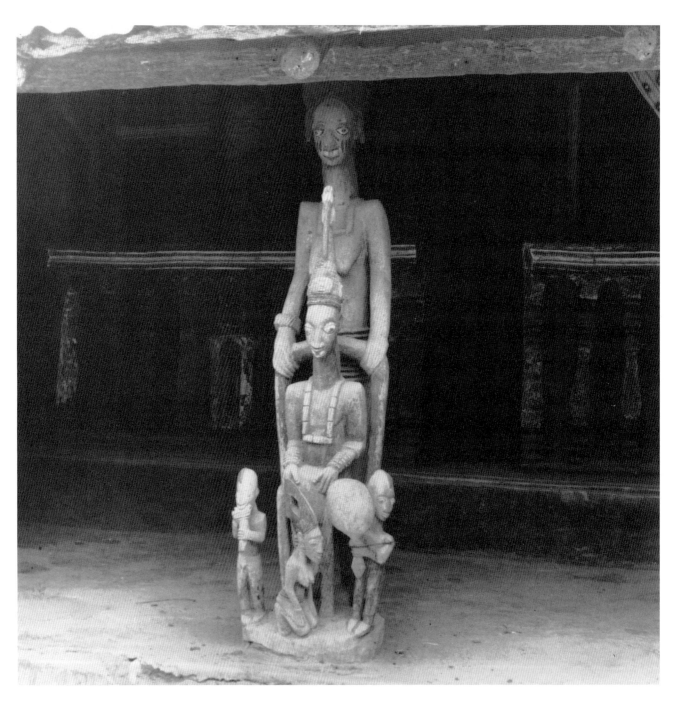

FIGURE 9. View of fig. 1, *in situ*.

picked up in the tail of the bird, forming a graceful curve with its counterpoint in the bird's bill as it touches the crown. The diagonal line of the queen's breasts continues in the jaw line of the king and is repeated in the lower arms of the king and queen. The pattern of the layer of beads around the queen's waist is reiterated in the beaded pattern of the crown. Through these visual associations of line and pattern, Olowe conveyed to the viewer the couple's intimate relationship.

The iconographic significance of this veranda post, and especially that of the seated king and his consort, cannot be understood until we consider one

other carving that completed the sculptural program of the veranda. The doors to the palace chambers immediately behind the sculpture of the seated king are among the finest by a Yoruba carver (fig. 10). They were carved in *iroko* wood by Olowe about 1916. With the permission of the ogoga and Olowe's consent, the doors were removed and sent to England for the British Empire exhibition at Wembley in 1924. The following year, the British Museum acquired them on the condition that it send the ogoga a throne designed to his specifications. Commenting on the exchange, Fagg observed: "That does not seem to me to have been a very good bargain for him, for the wooden throne is not a very distinguished piece of British craftsmanship. . . ."[5]

When carving the doors, Olowe chose to celebrate a moment in the history of the people of Ikere. The occasion was the ogoga's reception of Captain Ambrose, who was Travelling Commissioner for the Ondo Province in 1897. Captain Ambrose is seen seated in a litter, looking a bit haughty, very uncomfortable, and rather small in comparison with the king, who is seated in the opposite panel. Ambrose's retinue is depicted above and below him, and includes a figure on horseback, probably Reeve Tucker, Ambrose's assistant. Bound and shackled prisoners carry the commissioner's belongings. The ogoga, wearing his great crown, waits with quiet dignity for his visitor. His senior wife stands behind him. Other wives, palace attendants, and slaves are portrayed above and below the ogoga. Although the panel on the right is larger, the figures on the left are much more striking and certainly livelier. This carving may be unique in Yoruba art in its reference to an historical moment.

Some time after 1926, Olowe carved another set of doors for the Ikere palace (fig. 11). They are also fashioned from two pieces of *iroko* wood, but are divided into three vertical panels. The most important, in terms of the iconography and composition of the door, is the series of thirteen pairs of faces which appears just to the left of center. These highly stylized faces are markedly similar to those one finds on the beaded crowns of Yoruba kings (see, for example, the face on the crown worn by the king in the scene in the upper right panel). The faces appear to be identical, apart from variation in coloring and a change in the design of the headpiece beginning with the seventh pair from the top. The original design is reasserted with the eighth pair, but rejected in favor of the new motif for the remainder of the series. The change is probably of no other significance than to provide subtle and delightful variation.

The large panel on the right consists of five scenes depicting persons engaged in a number of different activities. The drummers and trumpeter at the top announce the king's presence. The seated monarch, wearing his great crown and holding a flywhisk, receives two important visitors. The king's senior wife stands to the side; other wives stand below. In the lower panels, slaves are supervised by palace officials; a palm-wine tapper is at work; and a hunter moves along the way. The two men engaged in a wrestling match refer to the contests that are held during *Odun Emira*, the New Yam Festival, when the local champion wrestler of the year is determined.[6] The narrow panel on the left provides scenes of Ifa divination and animal sacrifice. Below, the devotees of the various gods of the Yoruba pantheon make their

FIGURE 10. Olowe. Door from the palace at Ikere, c. 1916. Wood and paint; h. 232.4 cm. London, The British Museum. Among Olowe's most ambitious and important works is this carved door to the palace chamber, originally situated behind the Art Institute's veranda post. The images on the door depict the ogoga's reception of Captain Ambrose, the British Travelling Commissioner for the Ondo Province in 1897. It seems to be the only example in Yoruba art of a reference to a specific historical event.

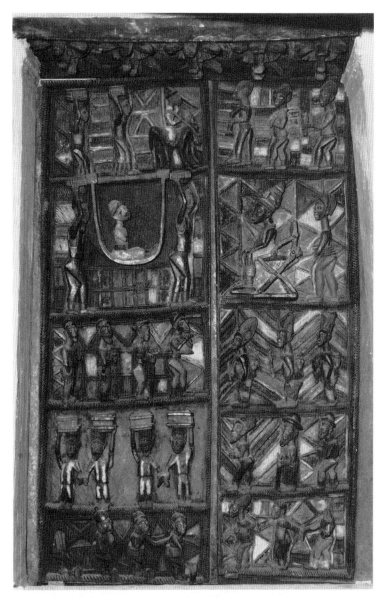

offerings. No narrative is to be read from the panels. Rather, as in the original Ikere door, Olowe carved a series of vignettes, hierarchically arranged, which celebrate the central authority of the king.

What distinguishes Olowe's doors is that he did not carve the figures in low and even relief. As Fagg observed: "Olowe, entirely on his own, seems to have introduced the practice of carving the figures to stand out at an angle from the door, so that the heads may project as much as six inches, whereas the feet are firmly attached to the wood of the single block from which the whole is carved."[7] Furthermore, Olowe painted his carvings, using different colors, along with the bold patterning of the background, to focus attention upon the king. He reserved the lighter shades of his palette to enhance the Ifa scenes on the left door.

It is important to remember that Olowe came from Efon-Alaye. Although he left town at an early age, he traveled widely in the Ekiti area and must have known the work of Agbonbiofe, the greatest carver of the Adesina

family in Efon-Alaye. Agbonbiofe died in 1945, seven years after the death of Olowe. As a result of the disasterous fire that swept through the palace of Alaye in 1912, Agbonbiofe was commissioned to carve twenty or more veranda posts for the various courtyards (see fig. 12). By 1916, he had completed the task and had brought renewed magnificence to the palace. Tragically, in 1930, zealots from independent African Christian churches burned many, perhaps most, of the "pagan" wood carvings that graced the courtyards and shrines of Efon-Alaye before they were stopped by Roman Catholic priests.

From the veranda posts and Epa masks that may be attributed to Agbonbiofe, it is clear that his two favorite subjects were the seated woman and the equestrian figure. Each is an image of power, not in the sense of strength, although physical strength is theirs, but of power as authority, which is conveyed in their poise, their *iwa*. The seated woman with a child on her back, her hands resting on the heads of two male figures, perhaps her twins, possesses a dignity and an authority that are her own. As stated above, the

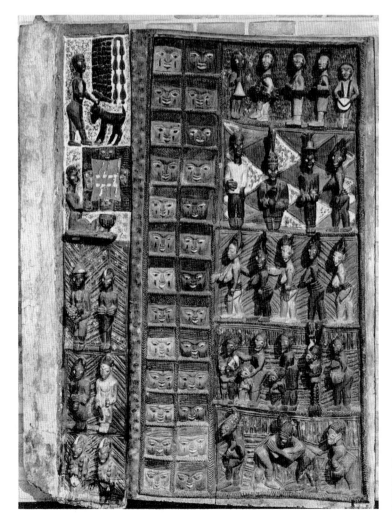

FIGURE 11. Olowe. Door from the palace at Ikere, aft. 1926. Wood and paint; h. 182.9 cm. Private collection. Photo: Bob Vigiletti.

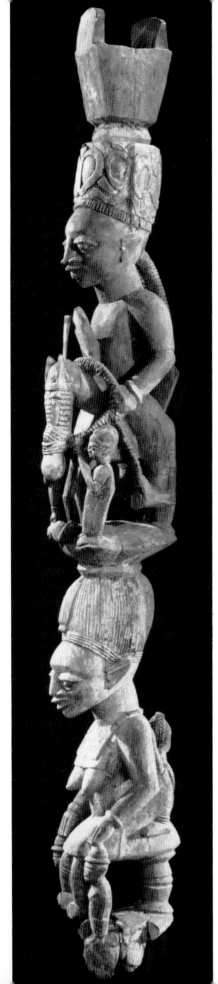

FIGURE 12. Agbonbiofe (Nigeria, Yoruba People, Ekiti, Efon-Alaye; d. 1945). Veranda post from palace at Alaye, before 1916. Wood and paint; h. 205.7 cm. New York, private collection. Photo: courtesy of Pace Gallery, New York, D. Allison, photographer. Agbonbiofe was another great Yoruba carver, from the same town as Olowe. He too did veranda posts for royal settings that Olowe must have known.

hidden power of reproduction and nurturing belongs to woman. Overt power, as in the hunt and war, belongs to man. He sustains life with death; she sustains life with life. In the social hierarchy of northeastern Yoruba society, the position of a woman is derived from that of her husband; and yet he is dependent upon her, supported by her, with respect to the continuity of his father's family. It is precisely the difference in roles, the disparate authorities that create them, and their interdependence that Agbonbiofe portrayed with great sensitivity in the veranda post shown here.

A comparison of the carving style of Olowe and Agbonbiofe reveals Olowe's preference for elongated, cylindrical forms and for the extension of his figures into the surrounding space, as compared with Agbonbiofe's more compact and closed forms. These observations apply when we observe the way in which each treated the subject of the kneeling female figure. The slim and beautifully decorated body, long neck, slender upraised arms, and soaring hair style of Olowe's female figures (see fig. 7) distinguish his carvings from those of Agbonbiofe, whose treatment of the same subject is sensitively understated (see fig. 13). Both carvers possessed what the Yoruba call *ifarabale*, or calmness, control, the mastery of ideas, materials, and tools. But Olowe also possessed *imoju-more*, a level of creativity and innovation that sets his artistry apart from the best of his contemporaries. The point is made by further consideration of Olowe's sculpture of the king and queen in the context of the entire sculptural program of the Ikere palace veranda.

In Olowe's arrangement of the sculptures, the seated king is the focus of attention. All action moves toward the ogoga, including that of the visitor to the palace courtyard. On the right, a mounted warrior approaches the king. On the left, a queen presents her twins. Behind the oba stands the senior queen. All of these figures are monumental, compared to the diminutive king, whose feet do not even touch the ground. As Olowe knew, and affirmed in the sculptures, it is not the figure seated upon a throne who is the focus of attention, but the crown. It is the crown that gives the man who wears it the authority and power of kingship; and it is the senior queen who, on ceremonial and ritual occasions, stands behind the king and places the crown upon his head.

In order to understand the composition and iconography of Olowe's ensemble more fully, we can draw upon the evidence of contemporary Yoruba ritual. The annual festival for the king in the neighboring town of Ila-Orangun, which the present author documented in 1984, reinforces the power of the crown and the significance of the person who wears it.[8] The festival is called *Odun Oro*, or Festival for All Spirits, and also *Odun Oba*, or the Festival for the King. This thirteen-day event involves large numbers of people in many diverse activities, some carried out collectively, others

FIGURE 13. Agbonbiofe. Kneeling female figure with cock. Wood and pigment; h. 42.6 cm. Amherst, Massachusetts, Jane and John Pemberton III collection. That Yoruba artists evolved individual styles can be seen in comparing works by the nearly contemporary Agbonbiofe and Olowe. The compact, understated figures by Agbonbiofe contrast with Olowe's elongated, cylindrical forms.

occurring in private places and at random moments. As the drama of the festival unfolds, its ceremonies commemorate a ritual conflict between the power of the king, based on his descent from Oduduwa, and that of the chiefs of the town, founded on their lineage. During the course of the festival, the king variously identifies with the chiefs and clashes with them. On the day of *Iwa Iyan* or *Ojo Awejewemu* (the day for eating and drinking), he wears the simple regalia of a chief and invites his rivals to a series of feasts stressing lineage chieftaincy. Later, however, during the rite of *Iwa Aso*, the chiefs snub the king by refusing his invitations, and their representatives engage in mock battles with his palace servants. The king, wearing the great conical and beaded crown of Ila-Orangun, witnesses the conflict.

Opposed to the public nature of *Iwa Aso* is *Isule*, in which the town's families, at first excluding those of the royal houses, petition their ancestors, place offerings before them, and perform sacrifices in homage. Eventually, the royal houses also perform this rite at the palace. The king pays further homage through sacrifice to the first settler and king of Ila, Orangun Igbonnibi.

This latter rite refers to the founding of Ila and reaffirms the division of authority between the king and the chiefs. According to Ila tradition, when Orangun Igbonnibi arrived at the present site of Ila, he found the house of Timo, a hunter. Timo welcomed the king and invited him to establish his palace opposite his house. In return, Igbonnibi conferred the title of Chief Obalumo on Timo in recognition of the hunter's claim to descent from a royal line in a distant town and on the condition that Timo acknowledge his authority. The rite, therefore, introduces political history into the festival, a "history" that may well preserve information about the past, but that also serves to establish a "charter" for present relationships, legitimizing the authority of the king and the status of the chieftaincy of Obalumo in Ila. The rite thus purports to refer to a time when the political order shifted from one in which a lineage head was the highest authority to a king-centered community.

The performances of *Iwa Aso*, coming before and after the many rituals of *Isule* held throughout the town in the compounds of patrilineages and at the palace by the princes of the royal houses, are public actions that bracket or ritually enclose the multiple private rites of *Isule*. The festival begins with the performance of divination rites in every compound to honor the ancestors and to determine the sacrifices to be offered later in the rites of *Isule*. On

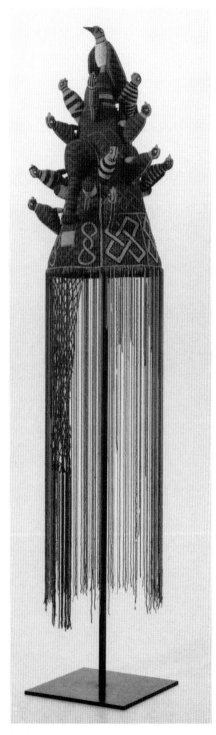

both occasions, the ritual emphasis is on the patrilineages and their primary significance for defining the social identity of the participants. But in the rite of *Iwa Aso*, there is the acknowledgment of an alternative referent for defining Yoruba social identity, namely, the king; and a deeply rooted conflict is disclosed regarding the relationship between kinship and kingship in defining the moral/political basis of Yoruba society. The conflict and the possibility of its resolution are enacted in *Iwa Aso*; and that reality surrounds, or ritually encloses, the celebrations of *Isule* by the patrilineages. Even during the period of *Isule*, as noted, the conflict is implicit, since the royal houses gather at the palace, not in their family compounds, to perform the sacrificial rites to their royal ancestors.

In addition to *Iwa Aso* and *Isule*, there are two final rites that reaffirm the king's power and reveal the source from which it partly derives: *Sakungbengbe* and *Isinro*. On the twelfth day of the festival, the queens of Ila, including the wives of former Oranguns, as well as the older wives of the present king, proceed from the palace to one of the chief's compounds in the ritual of *Sakungbengbe*. One of the three lineage chiefs of the town closely related to the palace, this chief is responsible for supervising the ritual obligations of the queens. His role, along with that of the chiefs who oversee the palace servants and act as messengers between the king and senior chiefs, indicates that little can happen within the palace that is not known by the town's chiefs.

In *Sakungbengbe*, the queens lead the chief to the king's market, where they dance and pay honor at the shrine of Amotagesi, the second Orangun, who reigned at Ila-Yara prior to the settlement of Ila-Orangun. According to palace historians, Amotagesi possessed powerful herbal "medicines" and once transformed himself into a beautiful woman in order to marry the Olowu, another "strong man in medicines," who had repeatedly waged war on Amotagesi. After seventeen years, Amotagesi, having learned the Olowu's secrets, transformed himself into a man and returned to Ila-Yara only to find that his son had usurped the throne. With the help of several chiefs and a mask called Egunsanyin, which was endowed with magical medicines, Amotagesi regained his throne. The ritual of *Sakungbengbe* thus introduces another moment in Ila's complex history in which "history" serves as "charter." It recalls a time when the king's ability to defend the town by military strength was inadequate and required the acquisition of hidden or covert power, one analogous to that which women possess in giving birth.

The final ritual is that of *Isinro*, which means burial or completion, and which revolves around elaborate displays of courtly etiquette between the king and the chiefs. In various rituals, the king, dressed in a magnificent

FIGURE 14. Nigeria, Yoruba People. King's crown. Beads and cloth; h. 101 cm. The Art Institute of Chicago, on loan from the Audrey and Milton Ratner collection.

robe and wearing a small beaded crown, receives homage from the chiefs of one of the compounds. Within his house, the chief, dressed as a woman, places his cutlass on the ground between himself and the king as a sign of peaceful greeting. In a gesture of recognition of the chief's authority within his own house, the king picks up the cutlass and presents it to the chief with prayers for his house.

When the king reappears in public, he wears the great conical, veiled crown of the Orangun-Ila (fig. 14). The chiefs, who are dressed in their finest robes, take turns dancing before the king. Finally, responding to the cheers of the chiefs and townspeople, the king dances before them prior to returning to the palace.

The ritual action of *Odun Oro* is two-fold. On the one hand, the locus of ritual activity moves from the many, separate private celebrations to a corporate, public ritual. The logic of the movement is to be noted in the sequence of locations of ritual activity. From the perspective of the public, the movement from diverse places of ritual activity in the compounds to the single-shared space is essentially a shift in sacrificial attention from the family ancestors and descent groups to the king and town.

In the *Oro* festival, we see the progressive identification of the symbols of power with the king as the animating center of Igbomina Yoruba society. For the Yoruba, the ultimate symbol of power is the crown (see fig. 14). It is the gift of the ancient Oduduwa to his "sons"; it is bestowed upon the one who wears it by the senior chiefs; it contains within it a packet of "powerful medicines" prepared by the herbalist priests; and it is placed upon the king's head by his senior wife. Sacred kingship is awesome. Thus, when the chiefs kneel before the Orangun, they greet him with the salutation: *Oba alaase ekeji orisa!* ("The king's power is next to that of the gods!").

We are now in a position to understand the iconography of Olowe's veranda post depicting the Ogoga with his senior wife. It is not the man but the crown that is the focus of attention and the locus of power. When the crown is placed upon the Ogoga of Ikere by the senior queen, his destiny, or *ori* (which, as we have seen, is also the same word for "head" in Yoruba), is linked to all those who have worn the crown before him.

But what about the great bird, whose long bill curves downward, touching the crown? Referring to the cluster of birds on his crown, the Orangun-Ila once said to this author: "Without the mothers, I could not rule." "The mothers" is a collective term for female ancestors, female deities, and for older living women, whose power over the reproductive capacities of all women is held in awe by Yoruba men. In Yoruba iconography, bird imagery refers to "the mothers."[9] Thus, the bird on the Ogoga's crown and the senior queen, whose breasts frame the crown, embody one and the same power: the hidden, covert, reproductive power of woman, upon which the overt power of Yoruba kings ultimately depends. But, as the positioning of the bird indicates, the power of the king is the crown, for it is an *orisa*, a deity. Hence, the crown is sacred.

Olowe, the master carver, understood the symbols of power in Yoruba society. In the Art Institute's sculpture of the king and queen, hieratic sculptural form accords with power relationships; aesthetics and iconography coincide.

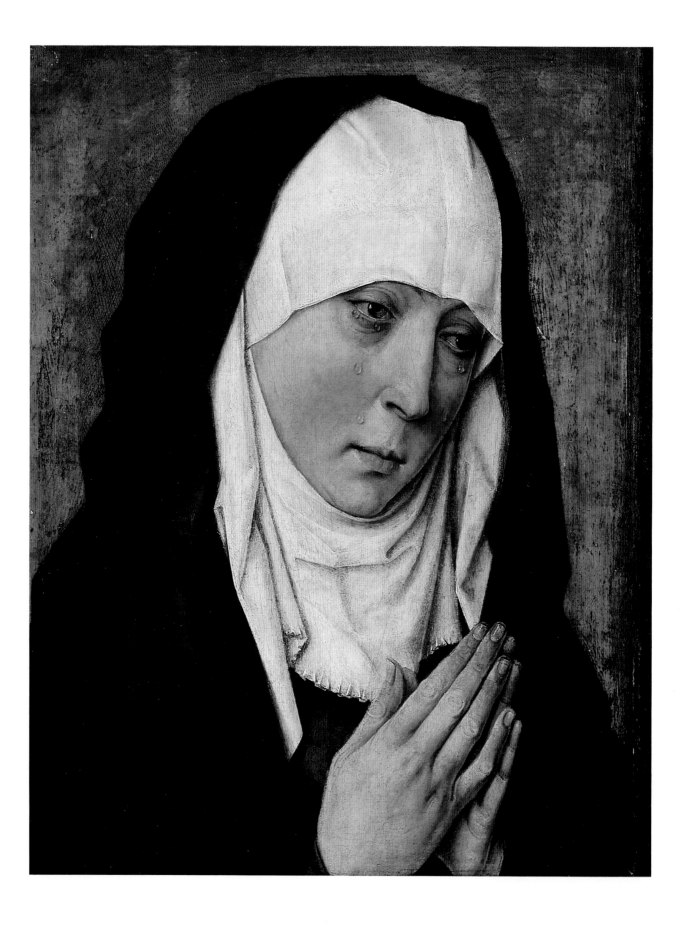

An Image of Compassion: Dieric Bouts's *Sorrowing Madonna*

MARTHA WOLFF, *Curator of European Painting Before 1750*

IN 1986, the Art Institute was fortunate to be able to add a particularly moving and beautiful devotional image, Dieric Bouts's *Sorrowing Madonna (Mater Dolorosa)*, to its small collection of early Netherlandish paintings (fig. 1).[1] Originally, this painting was paired with an image of Christ Crowned with Thorns, now lost and known only from replicas in which both images survive (figs. 2, 13, and 14). Together, the two images formed a diptych, or small private folding altarpiece. The Art Institute panel represents Bouts's highly influential variation on a type of devotional image already given form by his great predecessors. As such, it provides a vivid illustration of the way the achievements of fifteenth-century Netherlandish painting were built on a constantly renewed tradition and also of the way such intense and focused objects were used by their pious owners.

Bouts was born in the town of Haarlem in the northern Netherlands, according to Carel van Mander, the early biographer of Dutch and Flemish painters. He established himself in Louvain, near Brussels in the southern Netherlands, certainly by 1457. He had married the daughter of a wealthy citizen of Louvain, probably by 1447 or 1448, judging by the age of their eldest son, Dieric. Where the elder Bouts was trained and whether he worked in Louvain from the time of his marriage are unclear. He died in Louvain shortly after April 17, 1475.[2]

Painters in fifteenth-century Flanders and Holland demonstrated an extraordinary ability to depict the texture and substance of the natural world, with Jan van Eyck's magically detailed paintings representing perhaps the furthest advance in this direction (see fig. 3). Yet, they still belonged to a largely anonymous craft tradition. They rarely signed their works, and, as a result, their careers have had to be laboriously reconstructed from rare old biographies and surviving paintings, ac-

FIGURE 1. Dieric Bouts (Netherlandish, 1415–1475). *Sorrowing Madonna (Mater Dolorosa)*, 1470/75. Oil on panel; 38.8 × 30.4 cm. The Art Institute of Chicago, Chester D. Tripp Endowment, Chester D. Tripp Restricted Gift funds; Max and Leola Epstein Fund by exchange (1986.998). This recently acquired masterpiece is the left side of a two-paneled work, or diptych, whose other half, now lost, would have represented a Christ Crowned with Thorns. Together, the two panels belong to a category of private devotional images that enjoyed great popularity in fifteenth-century Flanders.

counts, inventories, and other documents. They painted the natural world not as an end in itself, but as a setting for holy figures, their subjects revolving around the two central mysteries of the Christian faith, the Incarnation and the death and Resurrection of Christ. Fifteen-century Netherlandish painting, for all its innovations, was, therefore essentially traditional. This traditional character was expressed both in painting styles, with artists clearly acknowledging the repertory of facial types and gestures used by their masters, and in the repetition of authoritative compositions. The interplay of tradition and innovation is an essential part of the meaning of these works and can be felt with particular intensity in intimate devotional paintings such as the *Sorrowing Madonna*.

In the Art Institute's painting, the Virgin is shown in an attitude of gentle sorrow, her head slightly bowed, her eyes brimming with tears, and her hands joined in prayer or supplication. Her gaze is directed out of the picture, yet seems deeply abstracted, inward and unseeing. The focus of her contemplation would have been the figure of Christ Crowned with Thorns, which originally formed the right half of the diptych, as is known from numerous copies in which both images survive (fig. 2).[3] As these copies indicate, Christ, too, would have been lost in melancholy contemplation. Though his pose is frontal and hieratic, his tearful eyes are also directed away from the viewer. The thickly-plaited crown of thorns and red

robe he wears refer to the mocking of Christ, that stage of the Passion when Christ was taunted as king of the Jews. The absence of nail holes in his hands confirms that the Crucifixion is still to come. Both figures are thus absorbed in contemplation of the sacrifice of Christ and the sins of mankind that made it necessary. By extension, the viewer would use this private altarpiece as an aid to his own meditation on the Passion of Christ. As we shall see, the painting derives its power from the way it excerpts, and makes timeless, a stage in the Passion narrative.

Private Devotional Images

The fifteenth century saw a great flowering of personal religious activity outside the formal structure of the mass. We can trace the heightened level and intensity of this activity through the spread of various aids to lay piety. Symptoms of this trend include the great proliferation of the book of hours, which was a flexible collection of prayers and readings to be used by individuals at stated intervals during the day; the popularity of such forms of prayer for the laity as the rosary; and the spread of relatively cheap devotional images, some connected with indulgences, in the new print media. The increased production of small private devotional paintings was part of this same trend.

FIGURE 2. Follower of Dieric Bouts. *Sorrowing Madonna* and *Christ Crowned with Thorns*, late fifteenth century. Oil on panel; 38.6 × 29.7 cm. and 38.6 × 29.4 respectively. Paris, Musée du Louvre.

114

FIGURE 3. Jan van Eyck (Netherlandish, c. 1390–1441). *Madonna of Chancellor Nicolas Rolin*, 1435/40. Oil on panel; 66 × 62 cm. Paris, Musée du Louvre. Among the achievements of fifteenth-century Netherlandish painters was their ability to render details and textures with an almost tangible realism, culminating in the paintings of Jan van Eyck.

In Joos van Cleve's *Annunciation* in The Metropolitan Museum of Art, New York (fig. 4), the relatively elaborate decoration of the Virgin's bedroom includes several aids to private devotion, as well as suggesting the inroads made by Renaissance ornament in early sixteenth-century Antwerp. To guide her prayers, the Virgin uses a book whose richly decorated margins indicate that it is a book of hours. Placed on a stand behind her is a small, portable altarpiece in the form of a triptych with the Old Testament figures Abraham and Melchisedek on its wings. Beside it, a much cheaper devotional image, a colored print, presumably a woodcut, is unceremoniously tacked to the wall. The half-length figure is readily recognizable as Moses because of his horns,[4] and would have been understood as the equivalent of a cult figure and antetype of Christ from the pre-Christian era. The Flemish painter has here transposed the devotional forms of his own day into the imagined usage of a privileged Jewish maiden before the coming of the Messiah.

Following the conventional lateral arrangement of the Annunciation, Joos placed the Virgin in front of her richly decorated room, rather than in it. In actual practice, a woman praying would very probably have positioned her prie-dieu to face the triptych and then read her book of hours before it. Numerous depictions of pious laypeople at prayer tell us that this was the way both prayer book and small devotional paintings were used. Some of these images go further by indicating the responses such aids to prayer were meant to evoke, help-

ing the individual visualize and focus on events in the life of Christ and the Virgin. Thus, in the dedication miniature of the Hours of the Maréchal de Boucicaut (Paris, Musée Jacquemart-André), the Maréchal and his wife are shown kneeling and saying their hours, as a radiant vision of the Virgin and Child appears before them.[5] The medieval psychology of prayer held that images helped the faithful put aside everyday reality, serving as a starting point for meditation—whether on the biblical narrative, the human relationship between Christ and the Virgin, or the role of Christ as savior.[6] It follows that the more emotionally true their imagery, the greater was their evocative power.

An extraordinary illusionistic miniature in the Hours of Mary of Burgundy (fig. 5), painted about 1470 by an anonymous Flemish illuminator known as the Master of Mary of Burgundy, makes explicit the process of absorption in the holy story. In the foreground, a prayer book, like the manuscript the viewer would be holding in actuality, is open to a simple illustration of the Crucifixion. A rosary rests on a brocade pillow, presumably left there by the book's owner. Beyond it, through the window opening, the Crucifixion narrative is re-enacted in complex and emotional detail, as if real, though in fact it must be projected in the mind's eye of the viewer, that is, the user of the book.

The miniaturist's choice of a window opening to embody the process of meditation is a significant one and has analogies to panel painting of the second half of the fifteenth century. The window frame and the picture frame each mediate between the real world of the viewer and the realm of the holy figures, who are the focus of his or her devotion. This is particularly true of small devotional paintings presenting a half-length or bust-length view of a holy figure. The painting is then a portrait of the holy figure and partakes not only of the portrait's power as a record, but of the more active interconnection between the painted subject and the framed edge of the picture space that was usual for fifteenth-century portraits.[7]

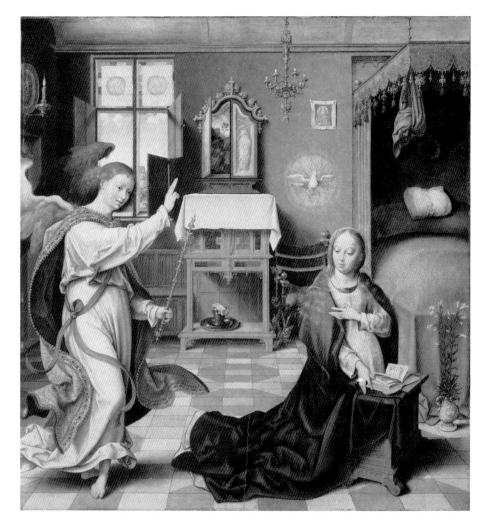

FIGURE 4. Joos van Cleve (Netherlandish, c. 1485–ca. 1540). *The Annunciation*, c. 1525. Oil on panel; 86.4 × 80 cm. New York, The Metropolitan Museum of Art. This painting includes several aids to private devotion in use in fifteenth- and early sixteenth-century Flanders. Among these are the book of hours the Virgin has been reading, the prie-dieu on which she kneels, and the small portable altarpiece on the stand behind her.

As Erwin Panofsky demonstrated, Rogier van der Weyden gave new life to the half-length format for paintings of the Virgin and Child, combining them with portraits of a donor into what has been called a devotional diptych.[8] In these works, the donor is depicted in perpetual prayer before the Virgin and Child, who occupy a separate panel which could be understood both as an actual portrait of the Madonna and Child and as a vision appearing before the donor's abstracted and contemplative gaze. In Van der Weyden's late devotional diptych, now divided between the Huntington Library, San Marino, California, and the Koninklijk Museum voor Schone Kunst, Antwerp (fig. 6 a, b), the visionary character of the Madonna image is underscored by its gold background, in distinction to the dark background behind the donor, Philippe de Croy.[9] Yet, the Christ

Child's playful activity on the brocade-covered pillow subtly hints at the possibility of connection across the boundary between the holy figures and the painted worshipper on the one hand, and between them and the actual worshipper using the diptych on the other.

Hans Memling, who was deeply influenced by Van der Weyden's forms and style, more literally suggested the possibility of crossing the boundary of the frame in a devotional diptych whose two halves were reunited at the Art Institute after a period of separation (fig. 7). In the portrait half of the diptych, the donor's elbow and edge of his prayer book overlap the sill of the frame, which has retained its original gilded and painted surface. In the other half of the diptych, the cushion and drapery of the Christ Child would almost certainly have overlapped their frame, now unfortunately stripped to

FIGURE 5. Master of Mary of Burgundy. *Christ Nailed to the Cross*, c.1480. Watercolor on vellum; 22.5 × 16.8 cm. Vienna, Oesterreichische Nationalbibliothek, cod. 1857, f. 43v.

FIGURE 6a, b. Rogier van der Weyden (Netherlandish, 1399/1400–1464). *Virgin and Child*, c. 1460. Oil on panel, transferred to canvas and reattached to panel; 49 × 31 cm. San Marino, California, Huntington Library. *Portrait of Philippe de Croy*. Oil on panel; 49 × 30 cm. Antwerp, Koninklijk Museum voor Schone Kunst [reconstructed diptych]. Van der Weyden is credited with having revitalized the devotional diptych, which combines a donor portrait with the image of the Virgin and Child. In this reconstructed diptych, the holy figures can be interpreted as a sacred vision appearing before the donor's rapt gaze.

the bare wood.[10] Such overlapping implies a continuity of the two parts of the painted space with our own, an effort to make the figures of the Virgin and Child accessible. This continuity is further reinforced by the reflection of a window and the heads of two little girls in the convex mirror behind the Virgin, as well as by the window onto a landscape uniting the two halves of the diptych.

The 'Sorrowing Madonna' and 'Christ Crowned with Thorns'

Private folding altarpieces with the Virgin and Child adored by a donor were produced in the Netherlands into the sixteenth century. Although the arrangement of the figures often showed the dominance of inherited models, the subject itself gave wide scope for subtle variations in the tender interaction between mother, child, and worshipper. The theme of the Virgin and Child expressed the humanity of Christ, and the half-length devotional diptych form made it accessible to the viewer because of its small-scale, portable quality and its portraitlike concentration. The other great theme for private devotional paintings was the isolated figure of Christ, who was represented according to two broad types: the Holy Face, and the Man of Sorrows or dead Christ. Both types claimed descent from what were believed to be miraculous portraits preserved in Rome.[11] Both types had a vigorous life in the fifteenth century,

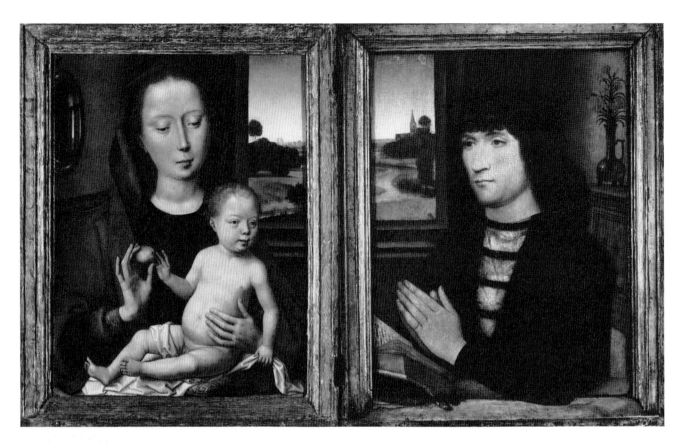

FIGURE 7. Hans Memling (Netherlandish, c.
1433–1494). *Virgin and Child with a Donor*, c.
1480/90. Oil on panel; 41.2 × 33.5 cm. The Art
Institute of Chicago. Left panel: Mr. and Mrs.
Martin A. Ryerson Collection. (1933.1050). Right
panel: gift of Arthur Sachs (1953.467). Memling
worked very much in the tradition of Van der
Weyden (see fig. 6a,b) but suggested a fusion of the
pictorial and real worlds. By allowing the donor's
elbow and prayerbook to overlap the sill of the
frame, Memling linked the space of the painted
figures to that of the viewer, thus rendering the
Virgin and Child more accessible.

when new and more emotional variations were
developed.

In formal terms, the descent of the holy face or iso-
lated portrait bust of Christ can be traced back to By-
zantine and early Christian imagery; yet, its authority,
in the late medieval mind, derived from its association
with a relic preserved in Saint Peter's in Rome believed to
be the veil with which Saint Veronica wiped Christ's face
on the way to Calvary. Christ's features were thought to
have been miraculously imprinted on the relic, which
was, therefore, a true portrait.[12] Even in Jan van Eyck's
version of the isolated portrait bust of Christ, known

only through copies, the stiff and hieratic character of
this icon type is evident (fig. 8). The head and shoulders
filling the picture space are strictly frontal. The eyes
stare impassively forward without engaging the viewer,
and the long hair carefully frames the smooth, regular
features. The elaborate cruciform halo and the inscrip-
tions on both frame and picture give the image added
authority. The fact that the copies seem to go back to
two slightly differing models bearing two dates within
Van Eyck's lifetime suggests that this was a venerated and
often-repeated image.[13]

The Eyckian *Holy Face* seems to exist outside of time
and space and to invite awe as much as contemplation.
Such an austere icon could be humanized, made accessi-
ble to the viewer, by adding the image of the Virgin,
thereby transforming it into a diptych. The combination
of the isolated bust of Christ and a corresponding medi-
ating bust of the Virgin was apparently introduced in
western Europe in the fourteenth century.[14] Fifteenth-
century Netherlandish painters fully developed the pos-
sibility it offered of combining the power and austerity
of an icon with the gentler pathos of a devotional image
as the focus for meditation. This process seems to have
begun with the two bust-length figures combined on a

single panel in Philadelphia attributed to the Master of Flémalle, who can be identified with the Tournai painter Robert Campin (fig. 9). Along with Van Eyck, Campin was the great originator of the new view of the natural world propounded by fifteenth-century Netherlandish painters. His Christ is, like Van Eyck's, a frontal, staring figure with smooth, regular features. Yet, the viewer is given a point of entry into the picture through the inclusion of the Virgin, who inclines her head toward Christ and joins her hands together in prayer as though soliciting his mercy on behalf of mankind. The addition of hands for Christ and the Virgin is a further important connection with the viewer, both through the counterpoint of their blessing and propitiating gestures and through the recognition of the physical reality of the frame that their placement implies. This latter aspect is most striking in the case of Christ's left hand, which appears to rest on the actual frame. Indeed, the startling tangibility of these figures set against their timeless gold background is characteristic of Campin's style and is an instance of the strong personal expression Netherlandish painters achieved within traditional forms.

The more accessible, empathetic character of this pairing of the portrait of Christ as Savior with a mediating Madonna becomes even more intensely felt in a related pairing, that of the Man of Sorrows with the Sorrowing Madonna. The image type known as the Man of Sorrows shows Christ upright, after the Crucifixion, but before the Resurrection, generally without signs of life and with the wounds of the Crucifixion prominently displayed. This type, too, came to be associated with a miraculous appearance of Christ, a vision of Christ displaying his wounds and surrounded by the instruments of the Passion, which appeared to the sixth-century Pope Gregory the Great while he was saying mass. Though this type too seems to have been linked to a specific, venerated icon in Rome, as it became widespread in the fourteenth century it was often combined with a mourning Virgin into a diptych and sometimes with a mourning Virgin and Saint John the Evangelist or other saint to form a triptych.[15] Such combinations imply an emotional and

more narrative connection between the figures—almost an analogy to a Pietà or Lamentation group—even as they isolate the figures as a focus for meditation.

By the second half of the fifteenth century, the rich associations of these traditional devotional types, coupled with the demand for heightened emotion in religious imagery, gave painters the opportunity to work out highly effective variations on a theme. The great popularity of Dieric Bouts's formulation came from the way he distilled the formal and emotional essence of these different images, creating a combination that evidently caught the spirit of his time. His achievement was to fuse the more emotional appeal of the Man of Sorrows and its references to the Passion narrative with the authority of the frontal portrait of the savior staring out of the picture space. The emotional appeal of Bouts's diptych is further intensified by having Christ share in the overt sorrow of the Madonna in a new way.

The representation of Christ in Bouts's diptych refers to a particular episode in the unfolding narrative of the Passion. As described in John's gospel, "the soldiers

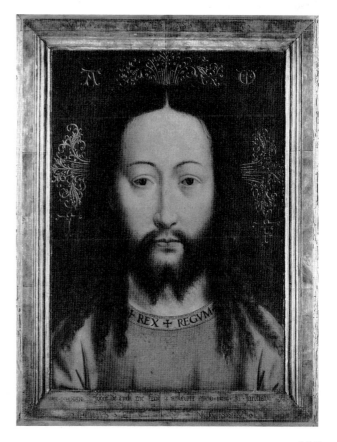

FIGURE 8. Copy after Jan van Eyck. *Holy Face*, fifteenth century. Oil on panel; 44 × 32 cm. Berlin, Staatliche Museen Preussischer Kulturbesitz, Gemäldegalerie. In addition to the depiction of the Virgin and Child, the rendering of the isolated head or half-length figure of Christ was the other great theme for private devotional paintings in fifteenth-century Flanders.

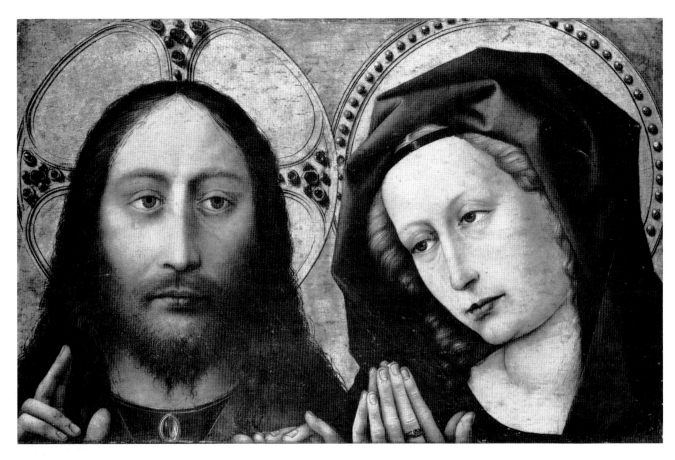

FIGURE 9. Robert Campin (The Master of
Flémalle, Netherlandish, c. 1378–1444). *Salvator
Mundi and Virgin*, c. 1440. Oil on panel; 30 ×
42.5 cm. Philadelphia Museum of Art, John G.
Johnson Collection. Campin softened the iconlike
austerity of the head of Christ by including a
depiction of the mediating Virgin.

platted a crown of thorns, and put it on his head, and
they put on him a purple robe, and said Hail, King of
the Jews! and they smote him with their hands. Pilate
therefore went forth again, and saith unto them [the
crowd] Behold, I bring him forth to you, that ye may
know I find no fault in him. Then came Jesus forth,
wearing the crown of thorns and the purple robe. And
Pilate saith unto them, Behold the Man!" (John 19: 2–5).
Pilate's presentation of Christ to the crowd for judgment
and his statement "Behold the Man," in Latin *Ecce
Homo*, is an important episode in the narrative leading
inexorably to the Crucifixion. In Bouts's diptych, the
robe and crown and the resigned expression of Christ all
evoke the *Ecce Homo* subject. Bouts seems to have been
the first painter to make this connection in the format of
an intense and private half-length devotional image.[16]

Nevertheless, other associations elaborate its meaning.
The stable, frontal pose also evokes the holy face or
portrait of Christ as savior. In this connection, it is inter-
esting to note that Bouts himself made a version of this
isolated face which, in its austerity, surpasses even the
Eyckian example.[17] At the same time, in the diptych, the
tears streaming down Christ's cheeks and the way his
gaze is internalized, avoiding the viewer rather than star-
ing directly at him, add a pathetic element not found in
depictions of either the *Ecce Homo* episodes or in icons
of the Holy Face.

This overtly pathetic, weeping Christ is another inno-
vation of Bouts's and parallels the way the Madonna is
presented in the diptych. Indeed, tears are most unusual
for the forbearing Christ of the *Ecce Homo* or for other
moments in the Passion narrative. Nor is the Virgin usu-
ally included in narrative representations of Christ pre-
sented to the people. Her quiet tears belong rather to a
Pietà, or Lamentation group. In Bouts's diptych, the
emotional states of the two figures are particularly close.
He thus gave pointed expression to the important late
medieval devotional concept of *passio* and *compassio*,
whereby, as part of a broad tendency to exalt the Virgin,

120

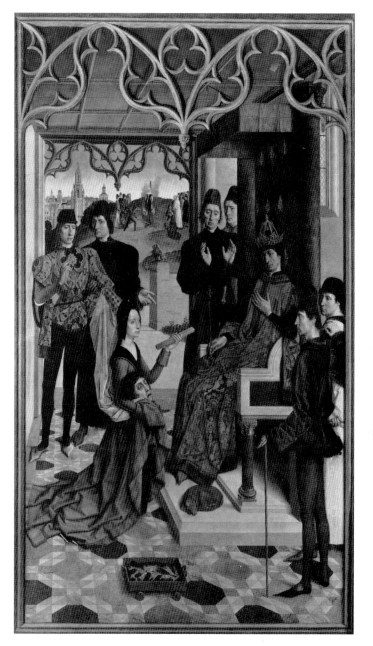

FIGURE 10. Dieric Bouts. *The Ordeal by Fire*, c. 1470–73. Oil on panel; 323 × 182 cm. Brussels, Musées Royaux des Beaux-Arts de Belgique. This is one of only a few works actually documented as by the hands of Bouts.

her empathetic participation in Christ's suffering and Passion leads to her being accorded a role in the actual process of redemption. Otto von Simson has shown how pervasive this notion of passion and compassion was in the fifteenth century.[18] It is striking that, in formal terms, the tearful expression of Bouts's Christ seems to be taken from the compassionate sorrow traditionally expressed by the Virgin. The way the parallel emotional states of Christ and the Virgin express the concept of *passio* and *compassio* must have been part of the power of Bouts's original diptych formulation and one of the reasons why it was so frequently repeated.

The Paintings of Dieric Bouts

The importance of the diptych as a pictorial invention is clear from an analysis of the tradition of private devotional images; but the attribution of this invention to Dieric Bouts and the preeminence of the *Madonna* in the Art Institute depend on what we know of Bouts as a painter. While we have only scanty and sometimes contradictory biographical information on him,[19] he is one of the more securely documented of fifteenth-century Netherlandish painters by virtue of the survival of two major works for which contract information is known. All other paintings are attributed to him on the basis of stylistic comparison to these key works, since no signed paintings survive. As a result, there has been a good deal of debate as to whether some works of very high quality are by Bouts or by his followers.[20] In a case like that of the Art Institute's *Madonna*, which is one of several versions of the same composition, quality and painting technique remain the most important evidence for ranking the different versions and identifying Bouts's own hand.

The two works documented to Dieric Bouts are the *Holy Sacrament* altarpiece in the church of Saint Peter's, Louvain, and the *Justice of Emperor Otto* panels now in the Musées Royaux des Beaux-Arts, Brussels. Contracts or payments for these documented works provide a chronological framework for the reconstruction of his oeuvre. The altarpiece of the *Holy Sacrament* was commissioned in 1464 and the final payment made in early 1468.[21] The *Justice* panels were part of a projected ensemble of four large paintings for the Louvain town hall that Bouts began to paint about 1470 and left unfinished on his death; one panel, *The Ordeal by Fire* (fig. 10), was finished by him, while another, *The Execution of the Innocent Count*, was left almost finished and completed by another hand.[22] Other paintings attributed to Bouts on the basis of stylistic similarity to these documented works include only one dated work, the *Portrait of a Man*, dated 1462, in the National Gallery, London.[23]

121

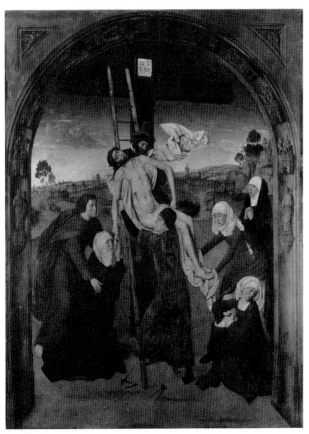

FIGURE 11. Dieric Bouts. *Descent from the Cross*. Oil on panel; 190.5 × 143 cm. Granada, Capilla Real. Photo: courtesy of Institut Royal du Patrimoine Artistique. The center of a triptych devoted to the Passion of Christ, this painting has been dated early in Bouts's career.

What are presumed to be Bouts's earliest works, particularly the altarpiece in the Prado devoted to the infancy of Christ, show a combination of earthiness reflecting his northern Netherlandish roots, design and figure type influenced by Rogier van der Weyden, and richness of texture and light recalling the art of Jan van Eyck. The tradition of Rogier van der Weyden prevailed in the austerity and linear grace of his mature paintings. Bouts's own great contribution is the elegance and economy with which he suggested the spatial ambience in which his reserved figures exist.

That the Art Institute's painting of the *Sorrowing Madonna* is the prime version of this influential type is an opinion held by numerous scholars, including Ludwig Baldass, Max Friedländer, Otto Pächt and Friedrich Winkler.[24] The chief dissenting opinion is that of Wolfgang Schöne, who felt that Bouts's autograph version of the diptych did not survive.[25] Those few scholars who have attempted to suggest any date for the Art Institute's

Madonna or for the diptych formulation in general, have also placed it relatively early, about 1450 to 1460, in association with Bouts's *Descent from the Cross* in Granada (see fig. 11).[26]

Changes made in the course of work on the Art Institute's painting and repeated in the other versions are an important indication that it is the prototype of the series, otherwise known only in workshop or later replicas. These changes are most evident in the fingers of the Madonna, which have been lengthened. The lower, first positioning of the fingernails can be readily made out as the superimposed paint layers have become more transparent with time. The longer fingers are repeated in the other versions. There are also numerous small adjustments to the folds of the veil, particularly to its right contour. The underdrawing in the Art Institute's painting, which can be made visible by means of infrared reflectography, places the features and folds and indicates areas of shadow with delicate hatching (fig. 12). Many contours were shifted slightly at the paint stage in relation to the underdrawing; the nose and lips were painted slightly larger than they were underdrawn as were the hands. A survey of as many versions as possible in terms of their underdrawn preparation and painting technique would undoubtedly help to group them in relation to the prototype. We know, for example, that copies were frequently prepared from a cartoon or pattern drawing whose pricked contours were transferred onto the panel, and that, in the early sixteenth century, Netherlandish painters began to use a more opaque painting technique instead of the thin, transparent layers of color favored by their fifteenth-century predecessors. This article can only serve as an introduction to such an investigation.[27]

Beyond these changes, the qualities that mark the diptych as a creation of Bouts can really only be grasped in Art Institute's painting. These qualities are, above all, sensual, in the treatment of light on flesh and cloth. In the eyes, light is transmitted through the hazel pupils and reflected in the reddened lids brimming with tears. It is reflected off the white veil onto the side of the face and shimmers through the cloth over the forehead, barely suggesting the shape of the brows and hairline beneath. These optical qualities are lacking in the other versions of the Madonna, as is particularly evident in the flat and undifferentiated treatment of the veil over the forehead in the versions in the Musée du Louvre, Paris, the National Gallery, London, and the Metropolitan Museum (figs. 2, 13, and 14), among others. In addition,

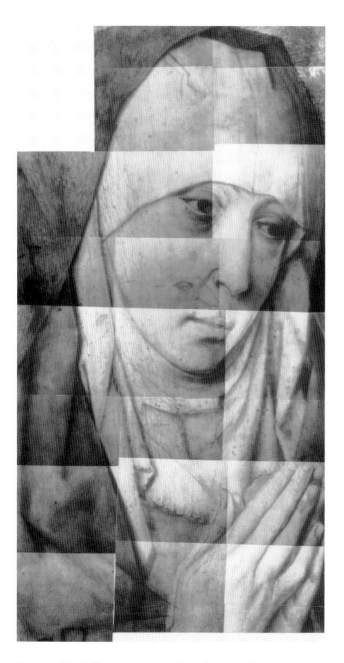

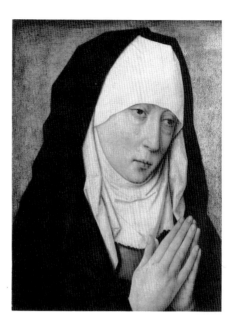

FIGURE 13. Follower of Dieric Bouts. *Sorrowing Madonna*, late fifteenth century. Oil on panel; 72 × 54 cm. London, The National Gallery. This painting is the left side of a diptych, which also depicts *Christ Crowned with Thorns*. The existence of numerous replicas of the Art Institute's painting (see also figs. 2 and 14) indicate the degree to which Bouts's diptych type captured the essence of late-fifteenth-century spirituality.

FIGURE 12. Reflectogram assembly of *Sorrowing Madonna* (fig. 1). In each Netherlandish painting, a drawing on the white ground layer of the panel typically served as a guide for the placement of the painted design. The underdrawing, here made visible by infrared reflectography, reveals that Bouts lengthened the fingers and enlarged the nose and lips in the final painting.

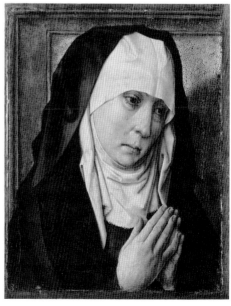

FIGURE 14. Follower of Dieric Bouts. *Sorrowing Madonna*, late fifteenth century. Oil on panel; 40.7 × 31.7 cm. New York, The Metropolitan Museum of Art. The right side, featuring *Christ Crowned with Thorns*, is not illustrated.

123

FIGURE 15. Detail of fig. 10.

while the details of the features and lighting on the face are quite exactly replicated in these paintings, they lack the feeling of life so striking in the Art Institute's painting. This is perhaps most evident in the lusterless treatment of the eyes.

While a sensitivity to effects of light is characteristic of Bouts throughout his career, the way he rendered light on flesh in the Art Institute's painting is found in very late works. Indeed, the early date usually given to the diptych seems to depend exclusively on a comparison of

facial types, in particular that of the Virgin to the mourning women in the *Descent from the Cross*. However, a distinction must be made between types used by Bouts throughout his career and the way they have been treated in the diptych. Thus, the head of Christ has much in common, not only with the resurrected Christ of the Granada triptych, but also with the frontal Christ presiding over the Last Supper in the mature *Holy Sacrament* altarpiece in Louvain—in the length of the face, very low placement of the mouth, and general flatness of

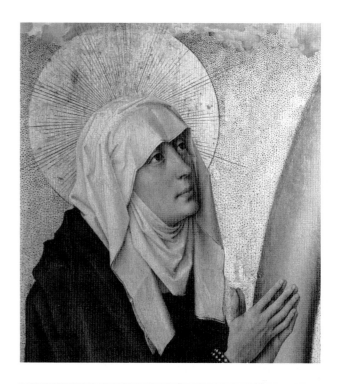

FIGURE 16. Rogier van der Weyden. *Last Judgment* (detail), c. 1450. Oil on panel; 135 × 560 cm. Beaune, Hôtel Dieu. This detail from Van der Weydens' large altarpiece demonstrates the degree to which Bouts was influenced by the art of this older master.

the facial structure.[28] The facial types of both Christ and the Virgin depend to a large extent on the work of Van der Weyden (see fig. 16). Yet, in the Granada triptych and other presumed early works, among them the Mary altarpiece in the Prado and a Madonna and Child known in versions in San Francisco, New York, and Florence, Bouts gave flesh a smooth, volumetric quality.[29] The firm, polished faces in these works and the tight handling of the paint seem to betray his Dutch roots and show an analogy to the contemporary works of his fellow north Netherlandish painter working in Flanders, Petrus Christus. In the Art Institute's Madonna, on the other hand, the paint handling is much looser, and there is a greater concern for the varied substance of the flesh: the folds around the eyes, the tighter skin over the cheekbones. These are still held in check by a nervous sense of line. The closest comparisons are to paintings from the very end of Bouts's career, the head of the virtuous countess from the Justice panel completed before his death (fig. 15) and the extraordinary *Portrait of a Man* in the Metropolitan Museum (fig. 17).

In the Art Institute's painting, the luminous treatment of the flesh serves to humanize the idealized features of the Virgin, which, as we have seen, Bouts had essentially derived from the elegant and spiritualized work of his predecessor, Rogier van der Weyden. This sensitivity to the effects of light and its use to heighten the emotional intensity of his works—bound as they are by compositional traditions—is characteristic of Bouts in both large altarpieces and intimate devotional works. In its concept, Bouts's diptych unites authoritative devotional types with the suggestion of a specific moment in the Passion narrative, making that moment timeless. In the execution of the Art Institute's *Madonna*, the combination of idealized features and translucent paint handling makes her a movingly human object of contemplation.

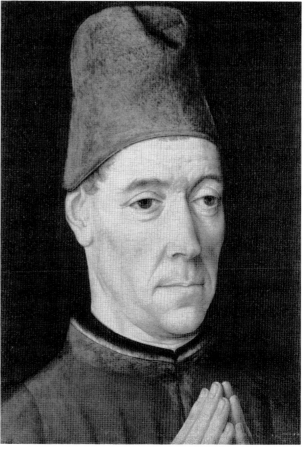

FIGURE 17. Dieric Bouts. *Portrait of a Man*, c. 1470/75. Oil on panel; 28.5 × 21 cm. New York, The Metropolitan Museum of Art.

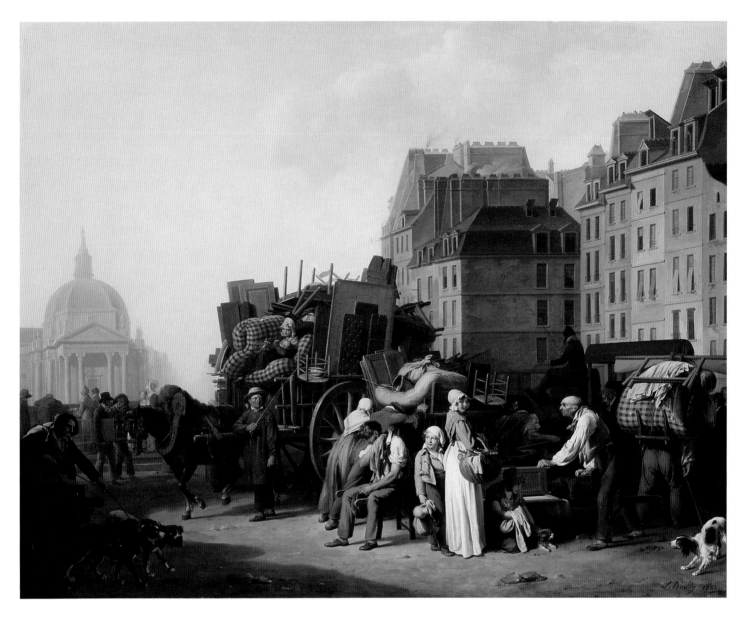

FIGURE 1. Louis Léopold Boilly (French, 1761–1845). *Moving House*
(*Les Déménagements*), 1822. Oil on canvas; 73 × 92 cm. The Art
Institute of Chicago, Harold Stuart Fund (1982.494). Boilly was a
popular genre artist. Genre paintings are traditionally considered to
depict scenes from everyday life. He also painted special and more
unusual events, such as the scene in this painting, depicting one of the
days that many of Paris's poorer renters moved from one set of lodgings
to another. A number of the details in the painting, such as the church
in the background, suggest that the image is more than a straightforward
representation of contemporary society.

126

Boilly's *Moving House*: "An Exact Picture of Paris"?

SUSAN L. SIEGFRIED, *The Getty Art History Information Program*

*I*N 1828, reflecting on his long and prolific career, Louis Léopold Boilly cited *Moving House (Les Déménagements)* (fig. 1) as one of six paintings that he wished to be remembered by, rightly considering it to be one of his best efforts.[1] The paintings in that group of six belonged to a series of large, urban genre scenes that Boilly had worked up for the official Salon exhibitions, which were held every other year or so in the Louvre. The series had its origins in the 1790s, when reforms brought about by the French Revolution opened up the Salon to previously excluded genre painters like Boilly and gave them access to the most important public exhibition space in Paris. A late work, *Moving House* stands at the end of this development. It is a fine example of the artist's mastery of the multifigure composition: complex arrangements of different episodes are tightly contained within the moderate scale of the painting, as compared with the unwieldy accumulation of figures that occasionally occur in his larger Salon paintings.

Boilly's Salon pieces not only aspired to a public scale; they also treated subjects that the artist deemed of general interest to the Salon audience. Turning away from the intimate boudoir scenes he had previously painted, Boilly drew his subjects from the repertory of events that constituted the public life of the city. *Moving House* depicts the bustling activity that took place about four times a year, when rent terms expired and the streets filled with poor people hauling their furniture as they set out in search of new lodgings. This was an unusual subject in painting. The only precedent one can point to is Etienne Jeurat's *Painter's Move* (1754; location unknown), which Boilly might have known through an engraving. Yet, Jeurat's broadly humorous approach to the central anecdote of the relocating painter is a far cry from Boilly's sober portrait of a social group. As we shall see, it is less to art than to literature that we must turn in order to understand Boilly's conception of his subject.

Boilly never lived to see *Moving House* enter a public collection, as he had hoped. When he exhibited this painting and the *Distribution of Wine and Food on the Champs-Elysées* (fig. 2) at the Salon of 1822, he even solicited the government's purchase of one of his works for the national collection by writing to the director of Royal Museums:

FIGURE 2. Louis Léopold Boilly. *Distribution of Wine and Food on the Champs-Elysées*, 1822. Oil on canvas; 90 × 130 cm. Paris, Musée Carnavalet. Photo: Lauros-Giraudon. Copyright: ARS, 1989 N. Y./Spadem.

In the thirty years that I have constantly exhibited at the Salon, the Government has never done me the honor of buying one of my paintings. It is true that I have never solicited this favor. Nevertheless, I would be flattered, Sir, to see one of my works placed in some royal gallery, and especially in the Luxembourg.[2]

His appeal was unsuccessful. In fact, Boilly had never had much luck in selling his important Salon paintings, owing perhaps to their awkward size and moralizing portraits of the crowd. Most of these works were still in

the artist's possession by 1829, when, ready to retire from painting, he organized a sale of the contents of his studio. *Moving House* was purchased from the 1829 sale by a distinguished collector, the Comte de Pourtalès, for the moderate sum of 660 francs.[3] From there, it passed through a series of private collections in France and the United States, and was so long sequestered from view that it was eventually considered lost. Rediscovered by Wildenstein's,[4] *Moving House* entered the collections of The Art Institute of Chicago in 1982, the first of several important works by Boilly that have come to light in recent years.

The re-emergence of *Moving House* in the public domain, for which it was originally conceived, provides an occasion to re-examine interpretations of the painting. These have centered on the idea that the painting offers an empirical record of its society. For instance, one

128

scholar recently described *Moving House* as exemplary of Boilly's "chronicle mode." Furthermore, when the painting was rediscovered in the early 1980s, discussion centered on identifying the depicted site (resulting in a revised title, *Moving House at the Port au Blé*), a discussion that assumed Boilly's depiction of the setting to be topographically accurate.[5] As we shall see, the setting and other features of the composition are far from straightforward, journalistic presentations of Parisian life in the first quarter of the nineteenth century.

This belief in the accuracy of the image is closely related to another idea, that the subject is homologous with the artist's life. The painting is thought to derive its authority not simply from the fact that Boilly painted what he saw, but also what he *knew*. For most scholars, this has meant that Boilly sympathized with the situation of the poor people he painted, and which he knew from first-hand experience. Thus, for Carol Eliel, Boilly was a socially concerned artist and *Moving House* was his way of "serving the interests of the working classes."[6] John Hallam adopted a more narrowly autobiographical view, seeing in the painting a reference to the relocation of artists from their studios in the Sorbonne, which took place in 1821 and may have affected Boilly. In this interpretation, no less than in the broader one, there is an underlying belief that, as Hallam put it, "specific subject matter [of the painting] may be directly related to the artist's own life."[7]

But what do we actually know about the "artist's own life?" The always-repeated facts of Boilly's biography are these: he came from a poor artisan family in the north; he married women who brought him no dowries; he sent his sons to school on scholarships, pleading poverty to the government; and he continually struggled to make ends meet. There is scant documentary evidence of this life story. Boilly, for instance, was not one to keep notebooks or write letters. There are perhaps a dozen of his letters extant, most of them remarkably uninformative. He left few traces in the archives of public institutions, and fewer still in the correspondence of important people, because as a genre painter he worked on the fringes of the official art world. He painted almost exclusively for a clientele of private collectors and did not leave an account book behind. The few documents that are known to exist concerning his civil status constitute the bare bones of his sketchy biography.[8]

This lack of biographical information has suited some scholars and biographers very well. They found that Boilly's life could be easily molded into a ready-made form, a romanticized myth of the impoverished artist.[9] For those more empirically inclined, the paucity of information has lent itself to a belief in the neutrality of the artist's position, which we can recognize in references to him as a "chronicler" or a "témoin" of his times.[10] The strength of this latter idea and its continuing appeal owe a lot to enduring conceptions of genre painting, which I will briefly consider.

For the most part, ideas about genre painting in eighteenth- and early nineteenth-century France have not changed much since that time. French genre painting depicting contemporary life is still being interpreted much as it was by its first audience, as a direct and accurate record of social realities.[11] The relationship between the painting and its subject matter is understood to be transparent. The work is thought of as a kind of window on the world, and everything seen through it— customs, costumes, incidents, interiors, exteriors—is regarded as a faithful depiction of the way things were. In Boilly's case, the general acceptance of his paintings as chronicles of his time has given them the status of sociological documents. They are often used to illustrate histories of France, of the city of Paris, and of costume, as well as studies of transportation and bourgeois forms of sociability and family life.[12] Sometimes, history is interpreted using the pictures. At other times, they are reproduced without explanation, as if the relationship between the subject under discussion in the text and that of Boilly's picture were self-evident. One begins to see why notions about the artist's neutrality are difficult to separate from notions about the objectivity of his work.

Yet, the genre painter's relation to his subject is not necessarily so straightforward as it at first appears. A close consideration of *Moving House* will point up some of the complexities of that relationship, complexities of which the artist himself may not have been cognizant.

Moving House was one of the last paintings Boilly sent to the official Salon exhibition, in 1822. Like most of the larger paintings he produced, this one was elaborate and calculated to amuse his public. Much of its potential to attract attention (this was no easy matter at the Salon) lay in the choice of subject. The common description of these works as scenes of everyday life is somewhat misleading, since Boilly's ambitious Salon paintings represented exceptions to the daily routine. His subjects included such special events as the arrival of a stagecoach, street entertainment in front of the Jardin

Turc, soldiers setting off for war, artists being honored at the Louvre, and the distribution of free wine and theater tickets at holiday times. In the case of *Moving House*, the event depicted took place a few times each year, when poor people packed up their furniture and set off in search of new lodgings. It was one spectacle among the other public spectacles of Paris.

I have said that the interpretation of Boilly's genre paintings as records of social reality was already in place at the time of their creation. We can appreciate something of this from Etienne Jean Délécluze's review of the 1822 Salon:

The caricatural paintings of Boilly, the *Distribution of Wine and Food on the Champs-Elysées* and *Moving House*, works that are not at all inferior to those the same artist made sixteen years ago, can give an idea of the progress the [French] school has made in the exact imitation of truth. One knows that M. Boilly has only painted with the idea of treating genre; the majority of those who distinguish themselves today have made studies for history [painting]. There is only one method of learning the art of painting, and that is to study nature severely.[13]

Small comfort to Boilly, the straw-man in Délécluze's attack on genre painting. The opposition the critic set up between history painting as the selective imitation of nature (*le beau idéal*), on the one hand, and genre painting as the exact imitation of truth, on the other, was deeply rooted in aesthetic theory of the eighteenth and nineteenth centuries. History painting had traditionally been so privileged in the hierarchy of genres that critics such as Délécluze did not spend much time explaining what they meant by phrases such as "the exact imitation of the truth." It was a catch-phrase, in the same way that "nature" was a key word for history painting. What was implied, however, is clear enough: that Boilly unselectively represented what he saw; that he simply copied things, without using his imagination to filter out the accidents and base aspects of nature. Furthermore, genre painters like Boilly imitated truth (not nature), which was another way of saying that they painted mundane reality. Délécluze would not forgive Boilly his choice of subject matter, and in referring to the paintings as "caricatural," he indicated the basic discomfort that most critics felt when confronted with scenes of contemporary life. It was hard to take these paintings seriously, especially when they traded, as Boilly's did, in the comic gesture.

Boilly himself seems to have subscribed to the theory of genre painting as a direct translation of reality. His description of *Moving House* suggested that

it was just a slice of Paris life: A wagon (loaded with furniture), hand-carts, stretchers, porters, cross a public place and go to the new residences of the tenants; here is another exact picture of Paris, when the rent terms expire.[14]

The impersonal character of the text says as much as the claim to accurate representation. The author may as well have been describing the physiognomy of Paris in terms of types of transportation, the way that Eugène Lami was to do a few years later in a series of prints.[15] Boilly gave another indication of his view of the painter's task in the figure of the artist he depicted in the background of *Moving House* (fig. 3). The artist walks along, carrying his easel and canvas, nearly drawn into the crowd of people hauling furniture. The painter, Boilly seems to have been saying, relies on first-hand observation; an activity he has witnessed on the street is recorded later in the studio.

Boilly and his critics notwithstanding, *Moving House* was no exercise in reportage. It was instead, I would suggest, the representation of an accepted, middle-class view of the poor. That view had been expressed for quite some time in the *tableaux de moeurs*, a type of literature that described the city of Paris, its inhabitants, and their customs. The model for much of this picturesque literature of the nineteenth century was Louis Sébastien Mercier's *Le Tableau de Paris* (1781–88). In a chapter entitled "Payer son terme," Mercier established the subject of poor people moving their furniture as a vignette of the working classes and their poverty:

In the *faubourgs*, there are three or four thousand households that never pay their rents. Every three months [when rents come due], they carry around, from attic to attic, furniture that is not worth more than eighty francs. They move from room to room without paying, and simply leave a piece of furniture behind as compensation, so that at the end of two or three years they do not have any more furniture.[16]

I do not wish to argue for Mercier's text as a source for Boilly's painting, but wish simply to point out that their conception of the subject was quite similar, as an examination of the setting and characters of Boilly's painting will make clear.

FIGURE 3. Detail of fig. 1. Boilly claimed *Moving House* to be a simple reflection of everyday life in Paris. Yet, the fact that he depicted a hearse moving toward a famous Roman church, Santa Maria del Popolo, in the background suggests he intended the painting to be a reflection on the transitory nature of life.

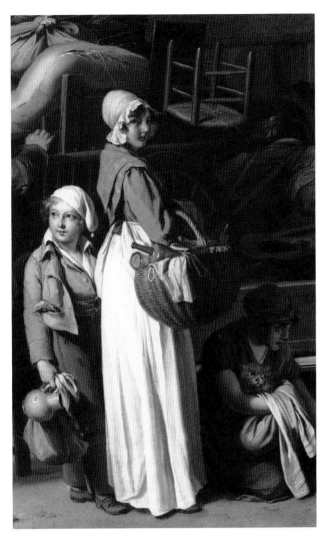

FIGURE 4. Detail of fig. 1.

Like Mercier (or the writers Nicolas Rétif or Etienne de Jouy), Boilly situated the poor in *les faubourgs*, those areas of the city that were specifically reserved for them in the middle-class imagination. The term "les faubourgs," as it was used by writers well into the nineteenth century, no longer referred to a topographic division, not even to the *faubourg* St. Antoine, so much as it did to a social division, the working-class populations that lived in certain areas of certain sections of the city.[17] This social geography shifted. Boilly set his scene in the Port-au-Blé, a small street jutting off the rue de Rivoli from the place de la Grève, in Arcis, then the heart of *les faubourgs*. In point of fact, the Port-au-Blé had been closed off to public access for seven years before Boilly completed his painting in 1822.[18] However, the actual status of the place was less important to the artist than its reputation as a particular site of the working classes.

Boilly also drew upon a stereotyped imagery of the poor, the *petits métiers* or *cris de Paris* types (street vendors or hawkers) who figured so prominently in *tableaux de moeurs*, as they also had in Boilly's earlier paintings. In another section of Mercier's text, he described the poor who struggled to pay their rent. As his examples, the writer selected, from the available cast of characters of the *petits métiers*, the lowliest peddlers of refuse: "The *vendor of ashes for scouring*, the seller of *broken bottles*, the *gutter-scrape*, the *hawker of scrap-iron* and of *old hats* have their lodgings and pay a per capita tax for the right to rent a bed. When one sees all the streets populated at noon, one can't at first glance imagine where this world will put up by night."[19]

Mercier was reaching for a contrast between low-life types and the high rents they paid, which included a special tax on transients, in order to dramatize the injustices of a housing situation that victimized those who could least afford to pay. Boilly, on the other hand, was not campaigning for social reform, and his selection of *petits métiers* characters tended toward the charming and ordinary. In effect, Boilly softened Mercier's imagery. In the artist's hands, the *marchand de bouteilles cassées* (male seller of broken bottles) became a fresh young *marchande* (female seller of broken bottles), who turns to engage our attention (fig. 4). He placed her conspicuously in the foreground of the scene and worked out her pose in a separate oil sketch (fig. 5). Is she a mother, wife, daughter? No matter; her primary function is to associate the throng of movers with the marginal world of the *petits métiers*.

132

The artificial contrasts of young and old, rich and poor, that make up the picturesque are evident elsewhere in *Moving House*. In a preliminary drawing, Boilly used a handsome young model to study the figure of a man leaning on a hand barrow (fig. 6). The model was simply a convenience, however, for in the painting, Boilly transformed him into a gnarled caricature of old age (fig. 7). The mediating factor in this transformation was an imagined stereotype of urban workers. The old man conformed to an established, physiognomic type for working-class men, prematurely aged and made ugly by a life of hard labor—"vulcanized" was Balzac's term for the effects of the workers' physical deterioration.[20] The artist's detached process of picturing the poor is also inscribed in the very style of his drawing. The chalk lines are crisp, clean, and measured; they do not linger over tatters or tears. As a study of draped costume and its folds, the drawing, one might say, is academic, if one did not know that Boilly had never been academically trained.

If *Moving House* gives visual form to conventional imagery of the poor, how do we make sense of Boilly's claim that he had painted an "exact picture of Paris"? The truth or accuracy of the scene has to be understood in the context of received culture rather than in terms of any direct observation of reality or social customs. This is nowhere more evident than in Boilly's moralizing treatment of his subject.[21] He introduced thematic elements that remove the scene from the purported realism of a slice of Paris life. Behind the crowd of household movers, he included a hearse wending its way toward a church (fig. 3). The church is a famous one, but it belongs in Rome. It is Santa Maria del Popolo,[22] improbably included in a Parisian setting that itself conflates the street of Port-au-Blé and the quais along the Seine. In other words, Boilly's setting is a thoroughly artificial construction, in which any semblance of topographical accuracy has been sacrificed to a reflection on the transiency of life.

Boilly took some trouble to extract his theme of the eternal rhythms of life. He had not satisfactorily worked this out in his preliminary sketch (fig. 8), where the hearse moves toward an uncertain destination. Is that imposing Neoclassical building a church or could it be the Ecole de Chirurgie or perhaps the new Chambre des Députés? In the painting, however, Boilly clarified the religious symbolism of the building by replacing it with a domed, Roman Baroque church. Then he underscored

FIGURE 5. Louis Léopold Boilly. *Two Women* (study for *The Movers*), 1822. Oil on canvas; 34 × 22 cm. France, private collection. Photo: courtesy of owner.

133

FIGURE 6. Louis Léopold Boilly. *Standing Man Seen Three-Quarter-Length, Facing Left* (study for *The Movers*), 1822. Black chalk, heightened with white, on brown laid paper; 26.8 × 23.9 cm. New York, The Pierpont Morgan Library, 1977.38. While Boilly may have relied on direct observation from life for his figures, in his finished paintings, he often transformed such motifs into something quite different, such as the old man with a hand barrow. Here, a young model was transformed into an elderly man (see fig. 7).

the sense of closure by isolating the church from its surroundings and setting it against a rosy sunset, so that Nature chimes in with a poetic comment on the end of life's journey. In these modifications, he implied that moving house was nothing more than a rehearsal for the final move from this life to another. The economic circumstances of the people moving are diminished by the way Boilly encompassed their seasonal ritual of change within larger, natural rhythms, the cycle of time and the cycle of life. We are encouraged to overlook their poverty as the reason why they were always in search of lodgings. The moral of Boilly's story seemed very reassuring to one critic reviewing the Salon of 1822, who approved of the painting's "philosophical" perspective on the poor.[23]

I have been arguing that Boilly's painting belongs to an established, middle-class imagery of the poor. The strength and continuity of that tradition is confirmed by Jean Henri Marlet's *Tableaux de Paris* (1821–24), which was an extension of the proliferating literature of *tableaux de moeurs* into the visual arts. Marlet included a scene of *Moving House* in his series of seventy-two lithographs (fig. 9), possibly by way of response to Boilly's painting.[24] He visualized the subject differently, concentrating on a single family unit and emphasizing a social contrast between rich and poor that was an afterthought for Boilly, relegated to the background of his painting, where finely dressed ladies barely notice the furniture movers of the foreground. Yet, the material circumstances of the workers are once again minimized. We are meant to read Marlet's social contrast with a view

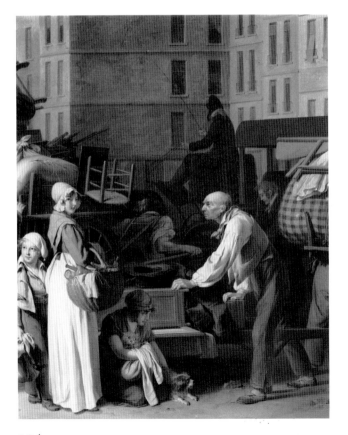

FIGURE 7. Detail of fig. 1.

to the moral superiority of the poor. This is made explicit in an accompanying text, which claims that honest workers are much happier than the rich man who hires porters to carry his vanity possessions. The author of this text, one Pierre Joseph Spiridan Duféy, also provided an explanation as to why poor people changed their residences so often. In his view, it was entirely a matter of whim:

Little personal property makes its changes on the 8th [of April and October]. Workers in rented rooms, ladies on half-income, clerks who escaped their supernumerary positions, an entire population of the rear-guard and the garrets is in movement. A seed of jealousy between husband and wife, quarrels of lovers, preferences, the well-being of a neighbor who is happier or more clever, all these passions that openly excite plebian households, and that are so nobly dissembled titled households, are the ordinary causes of these numerous changes of domicile.[25]

Here, economic considerations have been displaced by emotional or psychological factors: the frequent relocations of the poor were a physical expression of their emotionally volatile natures. Duféy's rationale and Boilly's cyclical rhythms were different versions of the same thing, a traditional view of the poor that saw only quaint customs and curious behavior and ignored social realities.

Louis Chevalier and Daniel Roche have drawn attention to the class-bound nature of this kind of imagery.[26] They have pointed out, for instance, that picturesque street vendors represented a highly selective image of the poor, since hawkers, who were not always picturesque, constituted only a fraction of the city's huge working-class population. The selectivity of such images reveals the tacit set of bourgeois values in these descriptions which are projected onto the poor.

Writing as a moral reformer, Mercier demonstrated in one example how underlying middle-class values surface in texts and images representing the poor. The whole point of his chapter "Payer son terme" was, so he said, to alert administrators to the injustices of the housing situation:

The poor man pays more for his apartment than the rich, and it is the same for everyone else. That it the most incontestable, the saddest, and most instructive truth that can be found in my entire book. I have written it only—dare I say it?—to inculcate [that truth], in different colors, in the heads of present and future administrators of the

grand police. It is by protecting the weak and poor that humanitarian laws develop their greatest wisdom; and by that that kingdoms honor themselves in the most distant posterity.[27]

The clue to the speciousness of Mercier's altruism is the phrase "everyone else." Earlier, he had switched his point of address, from a third-person account of the poor, to a direct engagement of his readers:

In the last thirty years, 10,000 new houses [have been built], and more than 8,000 apartments are empty. Well then, when you want to find someplace to live, you are very embarrassed because [there are so many] conveniences. One lives more grandly than before.[28]

It seems that Mercier was speaking here for the interests of the middle class; like the poor, "everyone else" who was not rich was having trouble finding houses and apartments they could afford. In Mercier's writings, the poor were not simply a pretext for discussing middle-class concerns, but they were partly that.

Duféy's commentary on Marlet's print offers another example of middle-class projection. His belief that the poor acted on their emotions was condescending, to be sure, and conformed with an old portrayal of them as childlike. At the same time, his rather far-fetched notion that they picked up stakes on whim seems to involve some wishful thinking. Does this not accord better with the dawning middle-class vision of mobility or freedom of movement, whether social, geographic, or architectural?[29]

As for Boilly, it is difficult to know whether his interest in cyclical patterns of change grew out of a conservative view of society, which held that its organization was ordained and unchangeable, or whether, in a more liberal vein, he was apologizing for the situation of the poor by placing it in the hands of Providence. Perhaps, as he turned sixty, he was simply reflecting on his own life and thinking about closure within the religious framework of his Catholic upbringing.

Middle-class projections of the poor are just another indication that such imagery cannot be confused with records of social reality. This was especially the case in the early 1820s, when Boilly and Marlet produced their works.[30] By that time, social issues had radically shifted, and perceptions of those issues were just beginning to change accordingly.[31] In Mercier's day, someone who lived in a furnished room could still be an object of

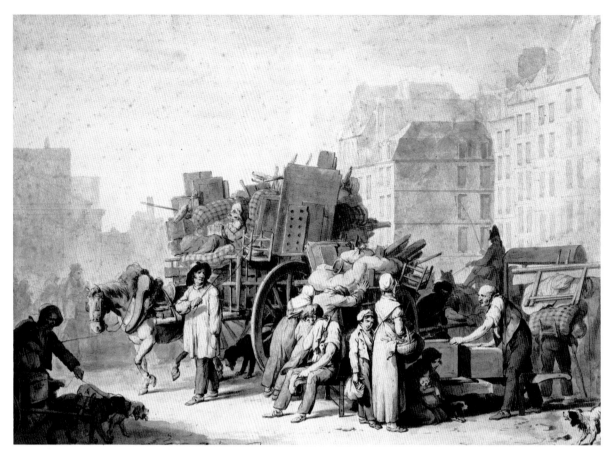

FIGURE 8. Louis Léopold Boilly. *An Intersection in Paris during the Moving Season*, 1822. Pencil, pen and black ink, gray wash, and watercolor on white wove paper; 46.5 × 65.2 cm. Lille, Musée des Beaux-Arts. This sketch is a preliminary version of *Moving House*. In it, Boilly had not yet determined the identity of the building toward which the hearse moves.

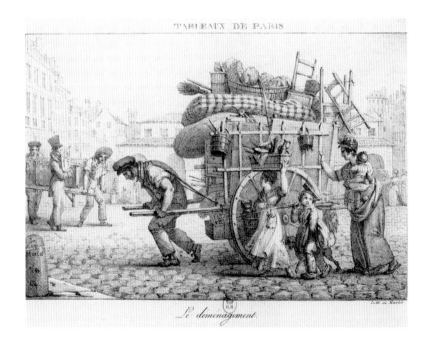

FIGURE 9. Jean Henri Marlet (French, 1770–1847). *Parisian Scene: Moving House*, 1821–24. Lithograph; 26 × 35 cm. Paris, Bibliothèque Nationale. In an image that represents the same subject as the Art Institute's picture (see fig. 1), the lithographer Marlet depicted a similar scene but emphasized the contrast between rich and poor.

136

satire. Mercier had one exasperated tenant remark: "Happy is the monk or the lodger in a furnished room! He is safe from these endless quarrels with the most insolent clerks in all the imaginable offices of this glorious kingdom."[32]

By the 1820s, the "population des garnis" (occupants of furnished rooms) was no longer a laughing matter. The combined efforts of the government and police were concentrated on identifying this floating population of transient workers who lived in furnished rooms. Quite improbably, they were held responsible for the staggering growth of the city's population. The fear that motivated such blame was evident in a modification of the census, which introduced a category for transients in 1817, and in weekly police reports on "maisons garnies" (furnished rooming houses).[33] The police kept track of men who had no homes, no families, and most important, no furniture. Furniture was the minimum investment a man could make to signify his belonging to the world of possessions and property. As one police report stated, such investment raised him above suspicion:

Furnished rooming houses also have lodgers, but those lodgers using furniture that belongs to managers should not be confused with lodgers living in private homes, who are comprised of workers chipping in together to buy their furniture and who, on that ground, are exempt from all police surveillance.[34]

In the context of this emerging definition of the "population des garnis," Boilly's and Marlet's representations of honest artisans moving house, burdened with furniture and families, belonged to a vision of the poor that was soon to vanish entirely. The desperate circumstances of the poor, beginning to be addressed in the census and police reports, had not yet penetrated middle-class consciousness.

It is just as difficult to construe Boilly's and Marlet's scenes as reactionary responses to the social issues of the 1820s. Boilly's painting and Marlet's lithograph were holdovers from the good old days, when urban society did not seem so grim, and reform so hopeless. Balzac, a much younger man than Boilly, was precociously attentive to statistical reports that the municipal government

was busy compiling, and he picked up on the pessimism that all those facts about material conditions of life in Paris began to exude. As early as 1825, Balzac incorporated into his novels remarks about the inequality of death.[35] This was a central, perhaps *the* central, realization for Restoration Paris: the recognition that poor people died younger and in greater numbers than others, and that the inequality of the mortality rate was the consequence and measure of unequal living conditions. If Boilly was aware of this depressing news, he did not let on in his painting. *Moving House* was still characterized by an optimism that implies that death is the greater equalizer and that, in spite of life's discomforts, everything will be all right in the end.

It is one thing to suggest that Boilly's painting represents bourgeois opinion, and quite another to suggest that the artist himself belonged to the bourgeoisie. Nothing much has ever been said about Boilly's social relationship to the subjects he painted, partially because so little has been known about the artist's life. The scant evidence has been interpreted as pointing in another direction, toward Boilly's failure to rise above the artisan class from which he came. Yet, as I have argued elsewhere, Boilly did not remain a mythical impoverished artist.[36] Rather, he retired from his artistic life, selling off the contents of his studio to invest his money in ways that would have been beyond the reach of the poor. He circulated his money shrewdly, investing in mortgage loans and continually reinvesting his capital. Far from being one of the poor he depicted, Boilly was financially entitled to the middle-class view we have seen represented in *Moving House*. In view of this evidence that his values were those of the bourgeoisie, we must reassess our assumptions that the relation between Boilly and the subjects of his genre paintings was a straightforward one. We must look with new skepticism at any pronouncements about that relation, even those of the historian A. Mabille de Poncheville, who did give some thought to Boilly's social status. We can recognize the romanticism that underlies his belief that Boilly identified with the poor he painted in *Moving House*: "Boilly himself, who lived poor and did not die rich, had known more than once what he recounted, the exodus of a family and its humble furniture."[37]

A Neoclassical Vase by Clodion

ANNE L. POULET, *Museum of Fine Arts, Boston*

CLODION (1738–1814) is best known for his small terracotta figures of bacchanalian subjects; the range of his work, however, was much greater than is generally realized. During the course of the 1760s, he created a series of small decorative vases in terracotta and, more rarely, in marble, which constitutes an important and neglected part of his artistic activity. Inspired by a blend of antique, Renaissance, and Baroque prototypes, he brought to these objects extraordinary technical skill and imagination. In 1987, The Art Institute of Chicago acquired a beautiful white marble vase (figs. 1–3) which is signed and dated on the top of the rim: *CLODION-MICH INVENTIT ET FE. IN ROMA 1766*. It is his earliest known signed and dated marble sculpture. The vase offers an opportunity for the study of Clodion's first maturity as an artist working in Rome, when he was under the heady influence of his discovery of ancient Roman, Renaissance, and Baroque art.

The vase is small, measuring only thirty-six centimeters in height. It is carved from a single piece of white marble and is solid except for a shallow cavity in the interior of the neck. Nothing is known about its provenance before 1930, when it was catalogued as being in the collection of Florence and George Blumenthal.[1] The body is ovoid, with a gadrooned pattern decorating its shoulder and lower register. The neck has a plain collar with three simple bands under the rim, while the foot is ornamented with two small bands where it joins the body of the vase, and with a wreath of laurel leaves around its base. Two extraordinary open-mouthed animal heads (fig. 3) adorn the springing point of the handles, which are formed by their crossed horns.

FIGURE 1. Claude Michel, called Clodion (French, 1738–1814). *Vase*, 1766. Marble; 36.4 × 19.9 × 18.3 cm. The Art Institute of Chicago, George F. Harding Collection by exchange; Harold L. Stuart Fund (1987.55). This small vase is the first known, signed and dated marble work by the sculptor when he was studying in Rome. His nine-year sojourn in the capital from 1762 to 1771 exposed him to the art of antiquity, the Renaissance, and the Baroque period, all of which profoundly influenced his creations of those years.

A continuous narrative scene in very delicate low relief encircles the body of the vase. On one side (fig. 1) is depicted a kneeling female figure pouring a libation from a *patera*, or dish, onto a fire on top of an altar with her left hand and holding a ewer in her right hand. On the other side of the altar, another woman kneels, her head lowered and her arms extended around the sides of the altar in a gesture of supplication. On the opposite face of the vase, a third woman kneels, holding two sacrificial birds (fig. 2) while, to her left (fig. 3), two kneeling female figures, their backs to the viewer, hold a ram, also probably meant for sacrifice. One of these figures also holds in her right hand a small ewer carved with fine incised lines, while, on her left, is a vase with a fluted neck and foot. A smoking urn on a stand also appears in the background.

FIGURE 2. Back view of fig. 1.

The figures are modeled with remarkable skill and subtlety, and they fill the space gracefully with a cadenced, dancelike rhythm in their poses and movements. Clodion played with the space allotted to the scene of women sacrificing by making their drapery overlap the band that serves both as the ground line on which they kneel and the separation of their space from the gadrooning below.

Clodion, whose real name was Claude Michel, came from a dynasty of artists in Nancy at the extreme eastern border of France.[2] He was the tenth child of Anne Adam and Thomas Michel. His mother's brothers were the famous sculptors Lambert Sigisbert and Nicolas Sebastian Adam, who had studied in Rome and then executed a number of works for Louis XV. Several of Clodion's brothers were also sculptors. He went to Paris from Nancy in

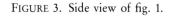

FIGURE 3. Side view of fig. 1.

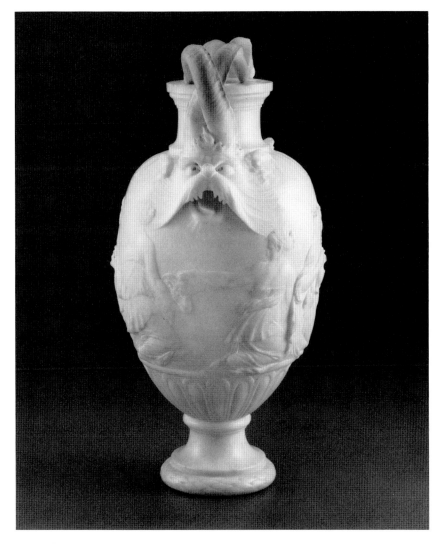

FIGURE 4. Clodion. *Vase*, 1760s. Terracotta; h. 24.25 cm., dia. of foot 9 cm. New York, Dalva Brothers, Inc.

1755 and worked in the studio of his uncle Lambert Sigisbert Adam until the latter's death in 1759. In that year, Clodion competed for and won the Prix de Rome. He then studied for three years at the prestigious Ecole des Elèves Protégés, a school founded in order to prepare the winners of the Prix de Rome for their stay in Italy. Through the study of Greek and Roman history and mythology, biblical iconography, and the works of revered artists, especially Raphael and Nicolas Poussin, the students were trained to appreciate the great collections of antiquities and Renaissance and Baroque art that they would see in Italy. Clodion left for Rome in the fall of 1762, arriving there on Christmas day. Although the Prix de Rome provided for three years of study at the Académie de France à Rome, at the Palazzo Mancini on the Via del Corso, Clodion stayed much longer. He remained in Rome for nine years until, in 1771, the Marquis de Marigny, who was Directeur des Bâtiments du Roi (Director of the King's Buildings), ordered Clodion to return to Paris.

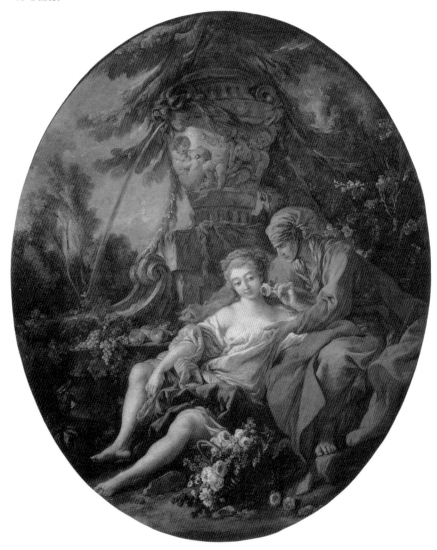

FIGURE 5. François Boucher (French, 1703–1770). *Vertumnus and Pomona*, 1763. Oil on canvas; 147.5 × 122 cm. Paris, Musée du Louvre. Photo: Georges Brunel, *François Boucher* (New York, 1986), p. 268. The vase depicted in Boucher's painting appears to be the same model as a terracotta vase by Clodion now in a New York collection (fig. 4). A version of the vase seems to have been in Boucher's collection. It can be associated with Clodion's style in the early 1760s, and probably predates the Chicago work.

Chicago's marble vase was done only three years after Clodion arrived in Rome. It is a highly accomplished work for a young artist of twenty-eight, and the inscription indicates his pride not only in having carved it, but also in having "invented" it. There is strong evidence that the Chicago vase was not Clodion's first work of art in this genre. A terracotta vase (fig. 4) in a New York collection is signed *CLODION* but is undated.[3] It is finely modeled and can be associated with his style in the 1760s. The same vase, or another version of it, appears in three different works by or after the French painter François Boucher: *Vertumnus and Pomona* (fig. 5); *The Prudent Shepherd*, now lost but exhibited in the Salon of 1763; and a drawing formerly in the Goncourt collection in Paris.[4] Boucher must have owned the terracotta vase by Clodion, an assumption that is supported by the following listing in the sale of Boucher's collection in 1771: "A vase decorated with a bacchanale of children in low relief, and with two masks with rams horns in relief from which fall garlands of flowers, by the same Claudion [sic]." The height listed in the sale catalogue also corresponds closely to that of the New York vase.[5]

It is not known whether Clodion executed the vase belonging to Boucher before he left for Rome in the fall of 1762 or after his arrival in Italy. In any case, in order to include it in a painting submitted to the Salon of 1763, Boucher would had to have had the vase by the summer of that year. Whether executed in Paris or Rome, the vase is close in spirit to Clodion's Roman sculpture.

Clodion's interest in antiquity as a source of inspiration dated from his earliest days in Rome. His friend and biographer Dingé wrote that as soon as Clodion arrived at the Académie, he began making terracotta sculptures inspired by Greek and Roman works which were so popular that they were purchased before they were finished.[6] Among these figures is a small terracotta statuette of Minerva signed and dated the same year as the Chicago vase: *CLODION./IN ROMA./1766* (fig. 6).[7] It would seem that Clodion took his inspiration for it primarily from the Minerva Giustiniani, an over-life-sized Antonine marble sculpture, now in the Vatican, copied after a Greek bronze of the fourth century B.C.[8] He may have also been thinking about a small marble figure of Minerva in the collection of Cardinal de Polignac which had been brought from Rome to Paris in the 1750s and was under the direct care of Clodion's uncle Lambert Sigisbert Adam.[9]

Like the Chicago vase, Clodion's Minerva was intended to be an independent, complete work of art, not a model for a larger sculpture. The difference between Clodion's antique models and his terracotta statuette is one not only of size and medium but also of mood and intent. Clodion's sculpture is infused with warmth and charm, and differs from its prototypes in a number of details, such as the shield. His intention was not to copy antique works slavishly, but rather to consciously refer to them while creating his statuettes and reliefs. This type of sculpture held enormous appeal for European aristocrats on the Grand Tour to Italy.[10] The objects were purchased as souvenirs of the great works of art they had seen and served as eloquent testimony to their avant-garde, Neoclassical taste.

This interest in antique sculpture was fed, in part, by the excitement over the excavations at Pompeii and Herculaneum that had begun in the late 1730s. A series of folio books entitled *Le antichità di Ercolano* was published

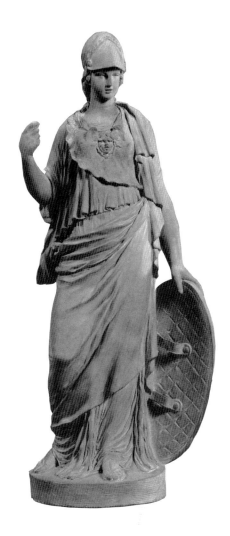

FIGURE 6. Clodion. *Minerva*, 1766. Terracotta; h. 47.5 cm. New York, The Metropolitan Museum of Art. Like Chicago's vase, this small-scale sculpture, inspired by ancient prototypes, was conceived as an independent work of art, not a model for a larger sculpture.

143

FIGURE 8. Joseph Marie Vien (French, 1716–1809). *The Selling of Cupids*, Salon of 1763. Oil on canvas; 96 × 122 cm. Fontainebleau, Château. Photo: Paris, Réunion des Musées Nationaux. Vien's painting was modeled after the mural reproduced in figure 7. When the French artist's version was exhibited at the Salon of 1763, it created a sensation because of its alleged faithfulness to the ancient original.

FIGURE 7. Engraving by C. Nolli of *The Selling of Cupids* from *Le Pitture Antique d'Ercolano* (Naples, 1762), vol. 3, p. 41, pl. 7; 25 × 35.2 cm. Cambridge, Massachusetts, Harvard University, The Library of the Fogg Art Museum. This engraving records a Roman mural painting discovered near Naples in 1759. After the publication of Nolli's book, this mildly erotic subject became enormously popular among artists throughout France.

in Naples and included engravings of paintings and sculpture found at Herculaneum. The first seven volumes appeared between 1757 and 1779. We know that Clodion owned volume 3 because it appears in the inventory of his possessions made at the time of his death in 1814.[11] One can imagine the interest generated among artists at the Académie in Rome as each of these volumes was published.

The third volume, published in 1762, included an illustration of a wall painting called *The Selling of Cupids* (fig. 7), which had been discovered near Naples in 1759. This mildly erotic subject subsequently became enormously popular among artists in Paris and Rome.[12] Joseph Marie Vien, a French artist and winner of the Prix de Rome in painting in 1743, who had become famous for his works *à la grecque*, exhibited a painting of the *Selling of Cupids* (fig. 8) at the Salon of 1763. Hung next to the engraving from *Le antichità* to illustrate how faithful Vien had been to his antique source, it caused a sensation. Nonetheless, as Robert Rosenblum has observed, there are as many differences as there are similarities between the painting and the print.[13] Clodion would have known about the success of the Vien painting through Charles Natoire, the director of the Académie in Rome who was in regular contact with Paris. The sculptor was among Natoire's favorite students and doubtless discussed the success of Vien's painting at the Salon with him.[14] A small, unsigned, and undated terracotta relief of the *Selling of Cupids* (fig. 9) by Clodion must have been done at about the same time and is far more faithful to its antique source than Vien's painting; although, as with the Minerva, the warm terracotta medium and the diminutive scale give it a charm that is unmistakably eighteenth century in quality.[15] This relief was published in the Abbé de Saint-Non's famous *Recueil de griffonis, vues, paysages, fragments antiques. . . .*[16] The aquatint is inscribed: *CLODION DEL. PEINTURE ANTIQUE D'HERCULANUM SAINT NON SC. 1773* (fig. 10).[17] Saint-Non was in Italy from 1759 to 1761, and he was a major force in bringing the study of antiquities to the attention of students at the Académie.[18] Clearly he considered Clodion to be part of the Neoclassical movement, and Clodion in turn was familiar with Saint-Non's interests and publications.

Saint-Non published another sheet in his *Recueil* (fig. 11), dated 1763, which depicts an ovoid vase similar to the Chicago work, with open-mouthed grotesque masks whose horns form handles. In addition, the altar shown on the lower left of the sheet resembles that in the relief scene on the Art Institute vase. This sort of design must have been in Clodion's thoughts when he created the Chicago vase. It is apparent that either Saint-Non's engraving provided one source of prototypes for Clodion, or both men were looking at and thinking about similar antique works.

FIGURE 9. Clodion. *The Selling of Cupids*. Terracotta; 22.2 × 27.6 cm. Boston, private collection. Photo: courtesy of the Museum of Fine Arts, Boston. Clodion's relief is much more faithful to its antique source than Vien's painting (fig. 8), although the warm terracotta medium and diminutive scale give it a charm that is unmistakably of the eighteenth century.

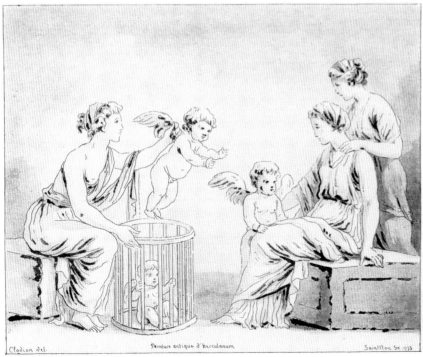

FIGURE 10. Aquatint by the Abbé de Saint-Non from Abbé Richard de Saint-Non, *Recueil de griffonis, vues, paysages, fragments antiques* . . . (Paris, [c.1790]), pl. 20, 16.4 × 19.9 cm. Cambridge, Harvard University, Houghton Library. The Abbé de Saint-Non traveled through Italy, often with other artists, making drawings of antiquities as well as Renaissance and Baroque works. These were subsequently engraved or copied in aquatint. The aquatint is inscribed "Clodion del. Peinture antique d'herculanum Saint-Non Sc. 1773," indicating that Saint-Non copied Clodion's relief in this work (fig. 9).

FIGURE 11. Engraving of various antiquities from Saint-Non, *Recueil de griffonis, vues, paysages, fragments antiques . . .* (Paris, [c. 1790]), pl. 13 (detail); 32.7 × 22.6 cm. Cambridge, Harvard University, Houghton Library.

In his pursuit of antique models, Clodion could also have availed himself of many great classical vases housed in Roman collections. The generic type of the Chicago vase is represented by the Borghese Amphora, a large, neo-Attic marble vase that exists in other versions in Paris and Naples.[19] Its ovoid shape with gadrooning at the shoulder and lower section of the body, the use of the central register for figures in low relief, and the small, round pedestal foot, as well as the volute handles, have all been incorporated into the Art Institute object.

In addition to studying original works, Clodion, who had been trained to work after paintings and prints, could also have studied the many vases represented in ornamental engravings. From the sixteenth century on, ornament books were filled with fanciful vase designs based on antique prototypes. A number of vase designs were also published in the eighteenth century, and Clodion was undoubtedly familiar with them. For example, Ennemond Alexandre Petitot, an artist who was championed by the Comte de Caylus and admired in Neoclassical circles, published a vase in 1764 that shares several features with the Chicago vase, including an ovoid body and a foot encircled by a wreath of laurel leaves.[20] The powerful sculptural quality of Petitot's engraving invites translation into a three-dimensional object.

The masks on the Chicago work also derive from classical and later prototypes, as they were often used to decorate vase handles in both antiquity and the Renaissance. In the later period, they became more fanciful and expressive and can be found adorning ceramic, stone, and marble vases. The masks on the Clodion vase, however, are a strange mixture of animal features, with their wagging tongues, hairy ears, long horns, and dolphinlike fins that blend very skillfully into the narrative space. Their energy, fanciful form, and lifelike expression remind one of Michelangelo's masks on the Medici tombs in San Lorenzo, Florence: for example, that on the breast plate of Giuliano de' Medici.[21] Clodion certainly knew the antique and Renaissance marble sculptures in Florence, since he stopped there on his way to Rome in 1762 and may have returned during the course of the 1760s. He would have admired the magical skills in carving marble of Michelangelo and Donatello, and it seems plausible that he had these artists in mind when he carved the Chicago vase. In particular, the delicate *schiacciato* (low relief) technique of carving the figures bears a close stylistic kinship to Donatello's marble reliefs such as the *Ascension of Christ* in the Victoria and Albert Museum, London.[22]

There were other well-known and more recent models for the masks available to Clodion, such as those depicted in the engravings of vases by Jacques Saly.[23] One plate in particular (fig. 12), dated 1746, shows a mask of an open-mouthed animal with ragged teeth, a feline nose, and long wispy strands of fur that blend into the surface of the body in a way that is strikingly similar to that in Clodion's work.

While a variety of prototypes from several periods underlie the design and ornament of the Chicago vase, Clodion seems to have drawn the subject of his narrative relief from the discussion of the cult of Vesta in Plutarch's *Lives*.[24] Apparently, the vase shows the attendants of Vesta, a Roman goddess whose cult was widespread in antiquity. Young girls, called vestals, were sworn to chastity and entrusted with the care of the goddess's temple as well as with the maintenance of a perpetual fire on an altar through the use of libations. Originally, there were six vestals, the number of figures shown on the vase. Those vestals making the sacrifice wore a veil over their heads, as do Clodion's figures who are adjacent to the sacrificial fire, while the others wore a turban-like headdress also shown on the figures on the vase. Where Clodion differs from the traditional iconography of the vestals is in the incorporation of animals for sacrifice.

Like other eighteenth-century artists, Clodion was rather free in his treatment of the subject, including elements from other types of sacrifice. Clodion's interest in the theme of vestals may have been reinforced by its popularity among other mid-eighteenth-century French, English, and even Spanish artists. For example, Vien painted *The Chaste Athenian Maiden* (fig. 13) at about the same time as the *Selling of Cupids*. The composition was engraved by Jean Jacques Flipart in 1763 and doubtless would have been known by Clodion and his fellow students in Rome.[25] The subject appealed to artists and patrons alike because it allowed the titillating depiction of beautiful young girls in a role of chaste devotion. Inevitably, ladies wanted to have their portraits painted as vestals sacrificing. An example of this type of allegorical portrait is the Art Institute's *Lady Sarah Bunbury Sacrificing to the Graces*, painted in 1765 by Sir Joshua Reynolds.[26] As this painting demonstrates, artists took great liberties with the iconography of their scenes of sacrifice, both in the use of antique visual sources and in the nature of the sacrifice and the deity or deities to whom it was being offered. The inventory of Clodion's studio lists such reliefs and statuettes vaguely entitled: *Offering to Love*, *Sacrifice to Love*, and *Vestal Sacrificing*.[27]

Clodion modeled a number of terracotta statuettes of vestals, one of which is recorded as being signed and dated Rome 1766, the same year as the Chicago vase.[28] While Clodion's statuettes of vestals reflect his familiarity with contemporary works by Vien and others, they also demonstrate his knowledge of antique representations of the subject. Saint-Non, for example, included in his *Recueil* an engraving of 1763 of a vestal pouring a libation on an altar with the inscription: *BAS RELIEF A LA VILLE PAMPHILE* (fig. 14). Clodion probably knew both the engraving and the relief from which it was made. A beautiful marble *Vestal* (fig. 15), signed and dated *CLODION. INV. FECIT ROMAE. 1770* and thought to have been commissioned from Clodion for Catherine the Great of Russia by her agent in Rome, has been shown to be based on an antique Roman vestal in the Museo degli Uffizi, Florence.[29]

FIGURE 12. Engraving of a vase from Jacques François Joseph Saly, *Vases inventés et dessinés par Jacobus Saly* (Paris, 1746), no. 6; 18.6 × 12.2 cm. Boston, Charlotte and Arthur Vershbow collection. Photo: courtesy of the Museum of Fine Arts, Boston. Clodion not only had antique vases but also collections of eighteenth-century engravings of vases such as those by Saly, which he used as prototypes.

FIGURE 13. Joseph Marie Vien. *The Chaste Athenian Maiden*, c. 1763. Oil on canvas; 89.5 × 67 cm. Strasbourg, Musée des Beaux-Arts.

While Clodion drew his themes from the classical era, the figures who enact the narrative are based on models from several periods. An Augustan sarcophagus relief showing a general's sacrifice and marriage was well known in Rome by the end of the fifteenth century.[30] In the right half of the relief is depicted a sacrifice at an altar and a kneeling figure holding a bull by the head. Clodion incorporated both elements in his narrative. He may have borrowed them directly or through an engraving after Raphael's painting of *St. Barnabas at Listra* in which the same figures appear.[31]

It should be remembered that the two artists whose works were held in highest esteem both at the Académie de France à Rome and at the Ecole des Elèves Protégés in Paris were Raphael and Poussin. Students were encouraged to study and make copies after their compositions, often through the

148

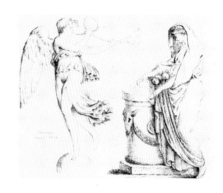

FIGURE 14. Engraving entitled "Bas Relief ant. à la ville Pamphile Saint Non Sc. 1773" from Saint-Non, *Recueil de griffonis, vues, paysages, fragments antiques . . .* (Paris, [c. 1790]) pl. 9 (detail); 32.9 × 23.2 cm. Cambridge, Harvard University, Houghton Library.

use of engravings. In the inventory made of Clodion's possessions at his death were listed a number of engravings, including several works after Raphael, folio engravings after the frescoes in the Farnese Gallery by the Carracci, and other unspecified engravings and drawings. Models for Clodion's female figures who kneel with their backs to the viewer, their heads in profile, can be found in several of Raphael's most famous paintings, as, for example, in the foreground of the *Transfiguration* (Vatican).[32] It is interesting to note that this figure appears in a plate in Saint-Non's *Recueil*.[33] Similar kneeling female figures appear in the left foreground of *The Fire in the Borgo*, in the Stanza dell' Incendio in the Vatican, and in isolated figures such as *Seated Woman With a Vase*, a sixteenth-century engraving after a composition by Raphael's pupil Giulio Romano.[34] Clodion and his confrères at the Académie were so imbued with these images that they formed an automatic part of the students' formal vocabulary. The contrapposto poses of the kneeling women on the Chicago vase create the illusion of movement in depth as well as a rhythmic pattern of line around the curved surface of the narrative space.

The subtlety of the carving of the figures on the Chicago vase recalls that of the marble *Vestal*, which was probably commissioned for Catherine the Great. The Chicago vase must also have been a special commission, since marble was such an expensive material that Clodion could not afford its use unless he had the support of a patron. To date, no archival evidence has been found to indicate who may have commissioned the Chicago vase.

Clodion was primarily a modeler, and clay was his preferred medium; however, he was trained to sculpt in marble and in stone, and he was a sculptor of exceptional technical facility in both. There is a terracotta version of the Chicago vase, one of a pair now in the Musée du Louvre, Paris (fig. 16), that is also signed and dated *CLODION IN ROMA. 1766*.[35] It is more than likely that the vase was initially conceived in terracotta and that the marble was commissioned once a patron had seen the first version. The Louvre terracotta is highly finished and virtually identical to the Chicago marble. It cannot, therefore, be called neither a *modello* or *bozzetto*. It is possible that the marble had a pendant, since the Louvre terracotta is paired with a vase of the same size and ovoid shape with a scene on one side of female figures flanking an altar, one of whom crowns the statue of a vestal placed there. On the other side, two vestals, one seated and one kneeling, have a small child holding a bird between them. It is interesting to note that this figural ensemble repeats with a few variations Clodion's relief of the *Selling of Cupids* (fig. 9) reinforcing the supposition that the relief predates or is contemporary with the terracotta vase.

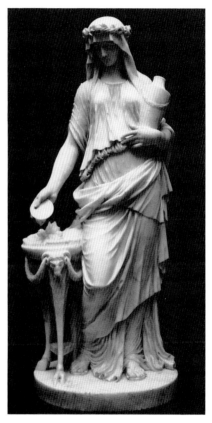

FIGURE 15. Clodion. *Vestal Sacrificing*, signed and dated 1770. Marble; h. 95.5 cm. Washington, D.C., The National Gallery of Art. The theme of vestals was very popular among mid-eighteenth-century European artists and appears in sculpture and paintings (see fig. 13). Its popularity derived, in part, from the opportunity it offered to combine antique subject matter with slightly titillating images of beautiful, chaste young girls sacrificing before altars or tending the fire of Vesta.

149

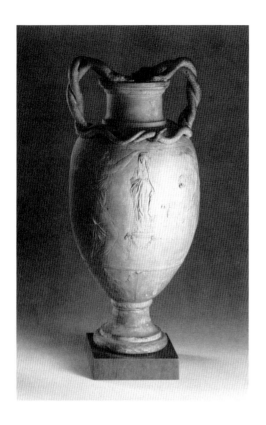

FIGURE 16. Clodion. *Vase*, 1766. Terracotta; 38.9 × 19.1 cm. Paris, Musée du Louvre, on loan to the Musée des Arts Décoratifs, Paris. Photo: courtesy of the Service Photographique du Musée des Arts Décoratifs. The Chicago work is the same model as this terracotta vase. It was probably after viewing the terracotta that the patron commissioned the marble vase in the Art Institute.

It has generally been believed that, until the nineteenth century, terracotta was a medium used by artists for *bozzetti* or *modelli*, or, in the case of a sculptor such as Clodion, for finished works of art, and that each work was created whole from clay by the sculptor. Yet, there is ample evidence that Clodion cast his terracotta figures (and vases), let them dry to a leather-hard stage, then added clay to model surface details before firing them. This technique is often used in the manufacture of faïence or porcelain figures and wares. An example of Clodion's probable use of this technique can be found in a terracotta version of the Chicago vase in The Detroit Institute of Arts (fig. 17), which is also signed and dated *CLODION IN ROMA. 1766* and is virtually identical to the terracotta in the Louvre. The only difference between the two narrative relief scenes is the addition of the head and shoulders of one female figure to the proper left of the figure holding two birds. This would reinforce the theory that, after casting the vase in a mold, its surface was worked and freshened by the artist. The smaller dimensions of the Detroit vase may be the result of shrinking after firing the molded clay. At one time, the Detroit vase seems to have been painted to look like bronze; a subsequent cleaning greatly damaged its surface. Yet, there is no reason to question its having been made by Clodion.

Clodion's vases were purely decorative and, like his reliefs and statuettes of the 1760s, were intended for a sophisticated international clientele. They were particularly appreciated by members of the French nobility who were deeply interested in Greek and Roman art and stood in the forefront of the Neoclassical movement. Even in antiquity, vases were primarily decorative, used in gardens and interiors, although they also served as funerary vessels or as containers for water and wine. Vases made in the eighteenth century at the royal porcelain factory at Sèvres were often designed to hold bulbs, plants, or cut flowers; however, Clodion's vases were not functional. The Chicago vase is solid marble and could not serve as a container.

Clodion modeled other vases in the 1760s, and they offer a telling view of the range of his skill and imagination during that decade. A superb pair of terracotta vases is in the Museum of Fine Arts, Boston (see fig. 18). Unsigned and undated, they must have been produced during the years in Rome. Their provenance gives some indication of the esteem in which they were held: they belonged to Mariette, appearing in the sale of his collection in 1775, became the property of the Prince de Conti, and in the nineteenth century belonged to the Goncourt brothers.[36] The form of the Boston vases derives from the famous Medici and Borghese vases, large marble neo-Attic Roman works that, after the Renaissance, were often paired in copies.[37]

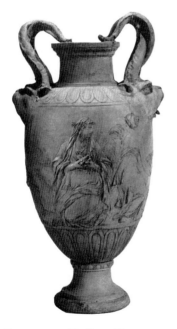

FIGURE 17. Clodion. *Vase*, 1766. Terracotta; 31.35 × 17.05 cm. The Detroit Institute of Arts.

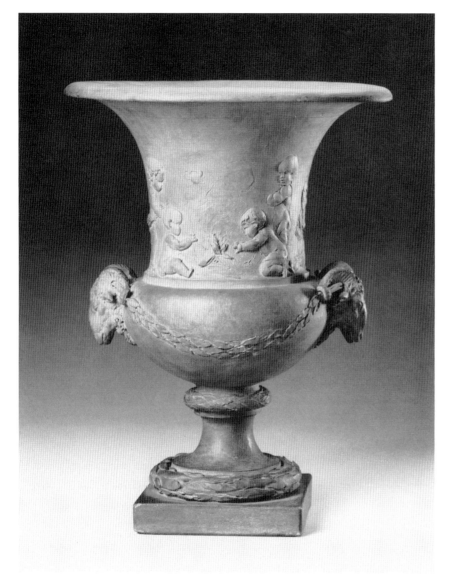

FIGURE 18. Clodion. *Vase*, 1760s. Terracotta; h. 27.7 cm., w. at rim 21.7 cm. Boston, Museum of Fine Arts. The reliefs on this vase, like those on the Chicago vase, reveal a blend of antique and later sources. In this case, works by the seventeenth-century French artists Nicolas Poussin and François Duquesnoy provided important prototypes.

Like the Chicago vase, these small terracotta works are decorated with beautifully modeled narrative scenes in low relief. Frolicking children, however, rather than vestals, are their subjects. They intentionally reflect Clodion's awareness of and admiration for two of Poussin's early paintings, *Putti with Chariot and Goat* and *Putti with Goat and Mask*, since they repeat, with certain variations, figures and decorative details of these canvases.[38] The Boston vases also demonstrate Clodion's knowledge of the bacchic reliefs of playing children by Poussin's friend and contemporary François Duquesnoy.[39] When Clodion translated these prototypes into his own delicate, low relief, he transformed them into a new and uniquely personal creation.

After Clodion returned to Paris in 1771, he was in great demand and formed a workshop in order to fill the large number of commissions he received through the early 1790s. One can see depicted in paintings of the

FIGURE 19. Anonymous, in the style of Clodion. *Vase*, mid-nineteenth century. Bronze; h. 33 cm., w. at masks 179 cm. Oxford, Ashmolean Museum.

FIGURE 20. Anonymous, in the style of Clodion (stamped *F. BARBEDIENNE*), *Vase*. Gilt bronze; 18.4 × 9.1 × 5.4 cm. The Art Institute of Chicago (1986.209). The popularity of Clodion's vases is attested to by the fact that they continued to be copied into the nineteenth century.

period Clodion vases of the same model in terracotta and gilt bronze,[40] with yet other versions known in plaster, bronze, and marble. He provided vase models for *bronziers-doreurs* (bronze- and goldworkers), *marchands-merciers* (dealers in luxury items and small wares), and for the Sèvres porcelain factory, making the dating and attribution of individual works very difficult in certain instances. For example, a pair of gilt-bronze vases signed *CLODION* and now in a private collection in New York, probably date from the 1770s, but Clodion only provided the model since he never worked in bronze himself.[41]

Attribution problems are complicated by the fact that Clodion vases were also copied throughout the nineteenth century. In the Ashmolean Museum at Oxford, there is a rather humorous bronze vase (fig. 19) with an animal foot for a base. This piece probably dates from the mid-nineteenth century and was made by an artist who, though working in a Clodion idiom, may have had no idea who Clodion was. Needless to say, the proportions and modeling have changed considerably from Clodion's original design. The beautiful Chicago marble vase was also copied in the nineteenth century, this time by one of the most famous French foundries, Barbédienne, as a gilt-bronze version in the Art Institute's collection attests (fig. 20). If it is compared to the eighteenth-century marble, one finds not only that it is smaller, but also that the shape of the body has been distorted, and rather fussy ornamental details have been added to the neck, lower body, and foot. Yet, despite these differences, this little vase provides evidence of the long-standing popularity and decorative potential of Clodion's compositions.

The exquisite works that Clodion created in the 1760s in Rome in terracotta and in marble constitute a new genre of sculpture. In every case, they are finely finished, inviting comparison with the modeling and carving of masters such as Donatello and Michelangelo. Yet, compared with the sculptures of his predecessors, Clodion's works of this period are diminutive in scale. This may in part be a practical matter, since the materials and space required to create small works were easier and less expensive to find. It also may be the result of his realization that the market for large sculptures in marble, particularly for the French crown, had dwindled greatly. He recognized a more ready and sympathetic clientele among the members of the French aristocracy. His little terracotta and marble sculptures were easy to transport and appropriate in scale for the more intimate interiors that had come into fashion in mid-eighteenth-century France.

Clodion's art in the 1760s reflected his enthusiasm for all he discovered in Italy, but his approach to this great resource was neither archeological nor scholarly. He used the rich visual vocabulary acquired through his studies in Paris and in Italy with a joyful abandon and an unswerving sense of composition and decoration. His biographer Dingé said of Clodion's sculpture: "The admiration that the precious remains of Greek and Roman antiquities inspired in him did not close his eyes to the beautiful works that had been created by the moderns; and, while studying the great masters, he sought, as they did, truth and beauty in nature."[42] The Chicago vase, because of its form, decoration, and medium, is one of the finest of the works Clodion created during his Roman years.

The Return of the Salon: Jean Léon Gérôme in the Art Institute

JACK PERRY BROWN, *Director, Ryerson and Burnham Libraries*

W hen we think of art in France in the last quarter of the nineteenth century, we think first of the Impressionists and Post-Impressionists, of Monet and Renoir, of Toulouse-Lautrec and Cézanne. The name Jean Léon Gérôme does not have for us the impact of these figures; yet, at the time, Gérôme (1824–1904) was one of France's—and the world's—most famous and honored artists.

With the possible exception of the painter Jean Louis Ernest Meissonier, it is hard to imagine a more successful artist in France during this time than Gérôme (fig. 2). The list of his awards and honors shows not only duration, but continued industry and recognition: third-class medal at the Salon of 1847; second-class medals at the Salon of 1848 and the Exposition Universelle of 1855; Chevalier de la Légion d'Honneur in 1855; professor of painting at the Ecole des Beaux-Arts from 1864 to his

FIGURE 1. Jean Léon Gérôme (French, 1824–1904). Detail from *The Chariot Race*, 1866–76. Oil on panel; 86.3 × 156 cm. The Art Institute of Chicago, George F. Harding Collection (1983.380).

death; member of the Institut de France, 1865; medal of honor at the Exposition Universelle of 1867; medal of honor at the Salon of 1874; member of the Conseil Supérieur des Beaux-Arts, 1876; jury member for the Exposition Universelle of 1878; Commandeur de la Légion d'Honneur, 1878; second-class medal for sculpture at the Salon of 1878; first-class medal for sculpture in 1881; *hors concours* (exempt from the standard competition for entry) at the Exposition Universelle of 1889. Gérôme's career, while not without some negative responses and a loss of critical esteem during his later life, was extremely productive (over 550 paintings and 75 sculptures) and successful. Yet, despite his renown, Gérôme and his art dropped from sight soon after the erection in 1913 of a monument to him in his native Vesoul, the town he left in 1840 to conquer the art world of Paris.

Gérôme was in his prime at the time the Art Institute was established in 1879. His art had been purchased by American collectors for more than thirty years when his first work entered the museum in 1893. The five examples by Gérôme in the Art Institute, acquired over a ninety-five-year period, span his career and represent

155

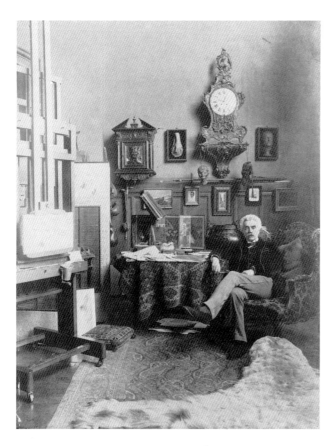

FIGURE 2. Jean Léon Gérôme (French, 1824–1904) in his studio, c. 1889. Photo: courtesy of Yale University Art and Architecture Library, Slide and Photograph Collection.

several aspects of his art. The group is comprised of three paintings, *Portrait of a Lady (Rosine Faivre?)* (1851), *The Chariot Race* (1876), and *Love Conquers All* (1889); and two sculptures, *Anacreon with the Infants Bacchus and Cupid* (1881), and *Bonaparte Entering Cairo* (1897). This diverse collection lacks only examples of his ethnographic paintings of the Middle East and his polychrome sculptures, and enables us to explore the very real talents of this reascendant artist.

The son of a provincial goldsmith, Gérôme was accepted into the Paris studio of the painter Paul Delaroche, where he studied until 1843. Delaroche, a student of Jean Auguste Dominique Ingres, combined the meticulousness of the Neoclassicists with the dramatic subjects of the Romantics, and helped to shift the serious field of history painting toward genre, or scenes of everyday life. Gérôme followed his mentor to Rome in 1844 and returned to Paris the next year, entering briefly the studio of the Swiss artist Charles Gleyre. Gérôme competed unsuccessfully for the Prix de Rome, a multi-year stipend for study at the French Academy in Rome, but he scored a *coup de foudre* at the Salon of 1847 with *The Cock Fight* (Paris, Musée d'Orsay), a painting the influential critic Théophile Gautier singled out for notice. At the age of twenty-three, Gérôme was famous.

In the 1850s, Gérôme did portraits, some state commissions, and depictions of the world of the Islamic east (Egypt, Turkey, and the Balkans), a theme that occupied him for the rest of his life. He later shunned portraits, doing them only for friends and family members; he also avoided state commissions after the mid-1860s, saying that he preferred they go to artists who needed the work. Gérôme himself became a very popular painter with collectors—most of his canvases are domestic in scale—and many of his works or variants were commissioned directly or purchased out of his studio. When Paris replaced Rome as the artistic capital of Europe at mid-century, Gérôme, along with his artist compatriots in the city, did a large and regular business with American collectors and entrepreneurs.[1]

Gérôme's popularity was assisted by his marriage in 1863 to Marie Goupil, the daughter of Adolph Goupil, an entrepreneurial picture merchant, who was one of the first to grasp the value of reproductions in expanding the market for works of art. Although Goupil's taste tended to exclude the fringe or more modern movements in art, his international firm, with offices in London, Berlin, and New York (as early as 1846), had the clout to ad-

vance his chosen artists. Goupil employed the latest technology for reproductions to showcase his artists, using engraving and, later, photography to imprint images on the public imagination. The publishing side of his business and his connections with the critics and mechanics of the Parisian art establishment could be and were used to enhance Gérôme's career.

Gérôme, along with Alexandre Cabanel and Isidore Pils, was appointed to one of the three professorships of painting at the Ecole des Beaux-Arts in Paris, a position he held for forty years, when the teaching structure of the school was changed in 1864 to provide a more structured curriculum for the students. The following year, he was elected to one of the fourteen positions allocated to painters in the Académie des Beaux-Arts, a division of the Institut de France. The Ecole, the official and most distinguished French institution for the study of painting, sculpture, and architecture, served until World War I as the model for art instruction, attracting students from around the world. Admission to each atelier, or studio, was granted by the *chef*, and each was run with extreme independence. Gérôme's atelier drew large numbers of foreign students, particularly Americans. Gérôme's influence on technique and composition can perhaps be seen most clearly in the work of Philadelphia artist Thomas Eakins, who maintained a lifelong relationship with his teacher after spending the years 1866–70 in Paris.[2] Several students described life in Gérôme's studio at the Ecole in letters or memoirs,[3] where they presented a sympathetic picture of the artist. He was an extremely popular teacher, respected if not loved, and was conscientious about his teaching responsibilities.

The sympathy recorded by his students provides an important counterpoint to the hostility caused by Gérôme's fierce opposition to the 1884 memorial exhibition of the paintings of Edouard Manet at the Ecole and to Gustave Caillebotte's important bequest in 1894 of Impressionist works to the French nation. Caillebotte, whose masterpiece *Paris, A Rainy Day* (1877) hangs in the Art Institute, was a friend of many Impressionist painters and left his collection of their works to the Musée du Luxembourg, then the state museum of modern art.

Over his long career, Gérôme was preoccupied with a number of themes: classical myths and history, ethnographic reportage of the Middle East, the nude, exotic animals (particularly the lion, which had an iconic symbolism for Gérôme because of his given and patronymic names), and a category that might be described as literal idealism, standing on its head Gustave Courbet's dictum, "Show me an angel, and I will paint it." Like Ingres, Gérôme reworked the same themes time after time over several decades, returning to them forty or more years after his first essays of them as a student.

The earliest work by Gérôme in the Art Institute is *Portrait of a Lady (Rosine Faivre?)*, signed and dated 1851 (fig. 3).[4] Gérôme made little mention of his portraits in his records and avoided the genre in later life, but a number of accomplished examples survive from this decade of his early maturity as a painter. Gérôme, like his contemporary Edgar Degas, preferred to limit his portraits to those of family members and intimates. Several members of the Faivre family, from the artist's native Franche-Comté, were friends of the artist's parents and of Gérôme himself. Dr. Benjamin Constant Faivre, of whom Gérôme did a portrait (now lost), went to Paris to treat Gérôme when he was wounded in a duel in 1861.[5] A chalk drawing (Neuilly, private collection) shows Gérôme's life-long friend Etienne Marie Faivre. Comparison of the Art Institute's portrait with a drawing of E. M. Faivre's wife, Rosine Thierry Faivre (fig. 4), and with an unfinished oil sketch of their daughter Marie Claudine Faivre (fig. 5) strongly suggests that the sitter depicted in the Art Institute's collection is Rosine Faivre.

Technically, the painting is brilliantly executed, albeit with a certain coldness. The direct frontal pose of the sitter clearly follows in the tradition of Ingres, although the monochrome background is darker than those in Ingres's paintings. A formal source for Gérôme's work may be the *Portrait of Mme Alphonse Karr* by Henri Lehmann (fig. 6), a student of Ingres, which he would have seen at the Salon of 1846.[6] Gérôme's composition is simple in the extreme, the fur trim of the sitter's green coat forming a powerful X-shape on the surface of the canvas when seen from a distance. The white highlights of silk in the sleeve and lace on the bodice illuminate the sitter's ivory face. The finish is nearly lapidary in its smoothness; even the rich depiction of the fur reveals no brushstrokes. The materials—satin, velvet, fur, lace—are painted with every bit of the mastery of Ingres. Yet, it is perhaps in Gérôme's failure to differentiate between these inanimate surfaces and the flesh, which becomes hard and polished here, that the sitter's interior eludes us. For all his obsessiveness with surface, Ingres always managed to express something of the character of those he portrayed; Gérôme here did not.

FIGURE 3. Jean Léon Gérôme. *Portrait of a Lady (Rosine Faivre?)*, 1851. Oil on canvas; 92.6 × 73.7 cm. The Art Institute of Chicago, restricted gift of Silvain and Arma Wyler (1964.338). Like his contemporary Edgar Degas, Gérôme preferred to limit his portraits to those of family members and intimates. Rosine Thierry Faivre was the wife of Gérôme's life-long friend Etienne Marie Faivre.

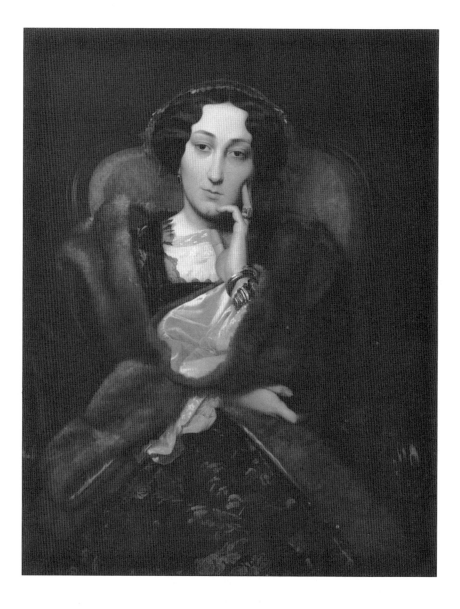

The glossy, reflective surface of this portrait also calls to mind the new medium of photography, which in the 1850s was seen primarily in the silvered shining form of the daguerreotype. The popularity in this period of the photographic portrait, led by such men as Gérôme's friend Nadar (Félix Tournachon) and witnessed by the fad for photographically illustrated *cartes-de-visite* and more formal studio works, threatened painted portraiture and led to its inexorable decline during the period of Gérôme's working life.

Gérôme's portrait can be contrasted to a nearly contemporary work by the great French Realist painter Gustave Courbet, also in the Art Institute, *Mère Grégoire* (fig. 7). As Robert Herbert has revealed previously in these pages, Courbet chose to depict a character from popular literature, a woman of less than respectable station and character, who challenged the repressive Bourbon monarchy.[7] On the other hand, Gérôme's subject is a solid member of the bourgeoisie: there is no hint here of the confusing and threatening events of the republican period following the overthrow of the July Monarchy in 1848 and of the subsequent rise to power of Louis Napoleon, nephew of Bonaparte. Gérôme, whose popularity and heights of inventiveness as a painter largely

FIGURE 4. Jean Léon Gérôme. *Mme Faivre*, 1848. Black chalk and gouache on paper; 33 × 24 cm. Paris, private collection. Photo: *Gérôme* (Vesoul, 1981), p. 39.

FIGURE 5. Jean Léon Gérôme. *Marie Claudine Faivre*, n.d. Oil on canvas; 51.5 × 44 cm. Paris, private collection. Photo: *Gérôme* (Vesoul, 1981), p. 103.

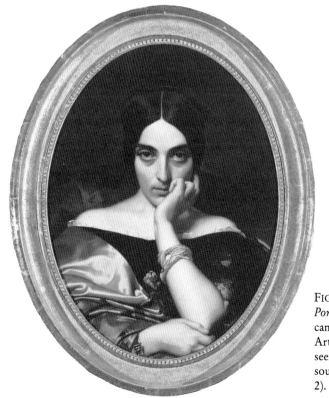

FIGURE 6. Henri Lehmann (French, 1814–1882). *Portrait of Mme Alphonse Karr*, 1845. Oil on canvas; 60 × 50.5 cm. Minneapolis Institute of Arts. This painting, which Gérôme would have seen at the Salon of 1846, was a possible formal source for his portrait of Mme Rosine Faivre (fig. 2).

159

FIGURE 7. Gustave Courbet (French, 1819–1877). *Mère Grégoire*, 1855 and 1857–59. Oil on canvas; 129 × 97.5 cm. The Art Institute of Chicago Wilson L. Mead Fund (1930.78).

coincided with the years of the Second Empire (1852–70), in this portrait appears to have been content with exteriors, happy to render with supreme facility the materials that successful industrialization in the period 1830–70 brought to the French middle class. His meticulous style, with its emphasis on absolute clarity of presentation, suited his audience well. As one contemporary writer stated in 1866:

. . . today, [that] which is given to study, to travel, which is accurate, mechanical, unimpassioned, which cares nothing for military glory, which dreads revolution, which wishes to *know*, which exalts knowledge and seeks for sensation, but is not poetic or heroic, is represented by Gérôme. Gérôme . . . the popular painter of France, is closest to the moral spirit and best shows the intellectual traits of his time. . . . He investigates like an antiquarian; he is severe like the classicists; he is daring like the romanticists; he is more realistic than any other painter of his time, and he carries the elaboration of surfaces and the science of design further than any of his contemporaries. Like the modern mind, he travels, he explores, he investigates, and he tries to exhaust his theme. He labors to leave nothing unsaid, to cover the whole of his subject.[8]

160

In an age when physiognomy had yet to be replaced by an understanding of interior psychology, Gérôme's portrait occupied a strong place, its interior impersonality balanced by its arresting visual presence and superb finish.

In the 1850s and 1860s, Gérôme's career flourished. He made extensive tours of the Danube valley, Turkey, and the Middle East, recording in his sketchbooks Eastern themes and motifs that would occupy him for half a century.[9] His paintings of life in the Moslem world are marvels of reportage, much more detailed than works on the theme by Eugène Delacroix or by Gérôme's teacher Delaroche, both of whom had visited Algeria a generation earlier.[10] The artist's exotic interests can be seen in the motifs and objects he collected on his lengthy and arduous expeditions to the edges of western civilization. Gérôme was not alone in France in his fascination with the world of Islam. The writer-sailor Pierre Loti, whose travels provided the raw material for steamy popular novels (e.g., *Aziyadé*, 1879) set in the Middle East and other distant locales, is a prime example of the French vogue for Turkophilia. Loti lived off and on in Istanbul and decorated his house in Rochefort *à la turque*. Much of this widespread interest was buttressed by the expansion of French capitalism; the French made heavy investments in the Islamic countries of the eastern Mediterranean, such as the financing of the Suez Canal. In fact, Gérôme was included in the official delegation that represented France at the opening of the canal in 1869.

Gérôme also applied his faultless technique to non-narrative subjects, depictions of racial and ethnic types, or genre scenes he had observed such as the activity of rug merchants and scenes of prayer. There is a strong architectural element in these pictures, numerically the largest component of Gérôme's oeuvre. In these works, the artist's strong sense of composition is coupled with and adds to the purely informational value of the exotic scene depicted, raising to the realm of considered art what in lesser hands would have been purely ethnographic illustration.

The oriental scenes include a strong element of eroticism. Ingres produced a number of pictures of imagined scenes in the harem or Turkish baths; Gérôme depicted the oriental nude explicitly. Works such as *Moorish Bath* (fig. 8) take the viewer into the forbidden space of the bath or harem with an almost cameralike objectivity, providing an architecturally correct and minutely observed setting and also approaching voyeurism in the intimacy of the scenes depicted.

A second of Gérôme's recurring themes is classical antiquity. His treatment of classical scenes embodies a mixture of extremely concrete detail, supported by painstaking technique and arduous archeological study and reconstruction, with prosaic subject matter and an almost banal literalness. Gérôme's vision of history painting became fused with genre: views of daily life in ancient times relieved of history. Occasionally, though, when he dealt with important events from ancient his-

FIGURE 8. Jean Léon Gérôme. *Moorish Bath*, c. 1880–85. Oil on canvas; 73.6 × 56.9 cm. The Fine Arts Museums of San Francisco, Mildred Anna Williams Collection (1961.29). An intense interest in the far-removed world of the Near East characterized many artists and their audience of mid-nineteenth century France. Not only did oriental themes have the allure of the exotic, they allowed the portrayal of erotic subjects in a non-European, and therefore acceptable, setting.

FIGURE 9. Jean Léon Gérôme. (Full view of fig. 1). A learned man as well as a talented artist, Gérôme maintained an endless fascination with the classical past. Consequently, it is a theme that surfaces in his work time after time.

tory such as the *Death of Caesar* (Baltimore, Walters Art Gallery), Gérôme had the ability to produce an image of memory and power. (Some of his earlier genre paintings from the 1850s and 1860s also have an enduring visual presence beyond their huge contemporary popularity, such as *Duel after the Masked Ball* [Baltimore, Walters Art Gallery].) But when he painted events of more literary or mythic origin, his depiction frequently smacked of voyeurism also, as in the Middle Eastern scenes. For example, in the famous *Phryné before the Areopagus* (Hamburg, Kunsthalle), the viewer is placed in the semicircle of the elders of the Athenian court, ogling with them the courtesan whose beauty acquitted her of charges of impropriety. No less a critic than Degas, discussing the painting as late as 1891, called it "pornographic," saying that Gérôme failed to understand the essence of the story.[11]

In *The Chariot Race* (figs. 1 and 9), the Art Institute possesses one of the prime examples of Gérôme's fascination with the classical past, which had begun when he accompanied Delaroche to Italy as a young student. Gérôme's youthful love affair with antiquity continued throughout his career, and his work is permeated from beginning to end with themes from classical times, either genuine events or genre scenes in an ancient settings.

Within this group, the Art Institute picture is exemplary in several ways. First, it was commissioned directly from the artist and was sold through Goupil, the artist's father-in-law, for the extraordinary sum of 125,000 francs.[12] The purchaser was A. T. Stewart, founder of the first department store in New York and an avid collector of contemporary European art.[13] Stewart, like the better-known Baltimore railroad entrepreneur W. T. Walters or W. K. Vanderbilt, found Gérôme's paintings and those of his compatriots in the official Salons to be extremely understandable and considered them to be on a higher plane than American works such as those of the Hudson River School; appreciation of contemporary European art was seen in the 1870s and 1880s as symptomatic of the coming of age of American culture. This taste for European, particularly French, official painting persisted to the end of the century. It

was the unusual American, such as Bertha Honoré Palmer in Chicago or the Havemeyers in New York, who departed in collecting tastes from the perceived values of the Salon painters.[14]

Because Stewart's collection was housed in his mansion on Fifth Avenue in New York, it was reasonably accessible and known to the public. His acquisition of the Gérôme was a major piece of news and was so reported by the young Henry James, who was working at the time in Paris, in his cultural column for the *New*

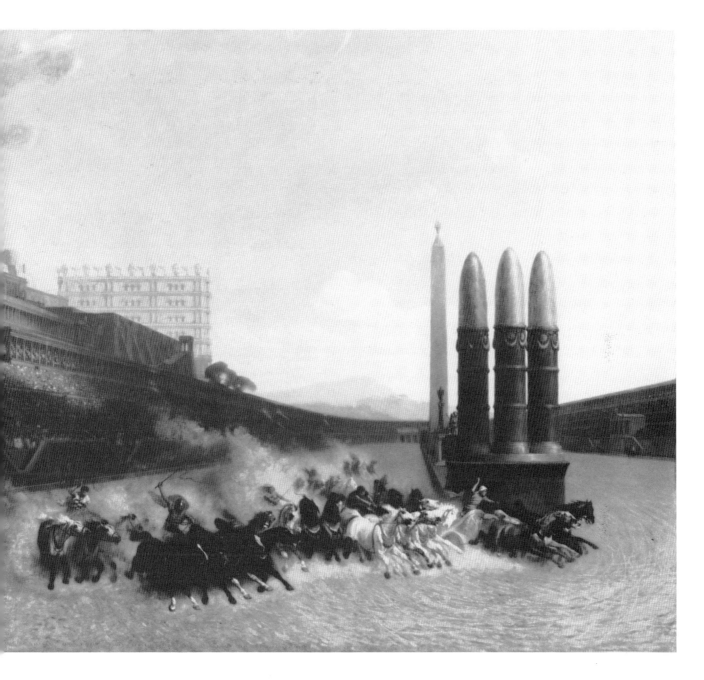

York Tribune. Although James found the picture less successful than Meisonnier's *Friedland 1807* (New York, The Metropolitan Museum of Art), which Stewart had also purchased (for the immense sum of $80,000), he wrote:

It is a capital example of the artist's archaeological skill. . . . It represents what I take to be the Circus Maximus on a day of high festivity; behind rise the towers, palaces, and terraces of the Palatine, and into the distance stretches away the vast ellipse of the arenaIt is a fierce *mêlée* of beasts, men, and wheels; the struggle and confusion are powerfully expressed, and the horses and chariots painted with that hard, consummate finish characteristic of the author.[15]

Both Gérôme and his patrons seem to have liked explanations of the intellectual content and effort involved in his compositions. In this regard, it is useful to cite a lengthy passage in a letter written by the artist describing *The Chariot Race*:

163

The scene is the "Circus Maximus," the grandest monument of Rome, which is situated at the foot of the Palatine Hill, in such fashion as that all the structures erected on the hill were contiguous to the Circus, thus giving a picturesque and imposing aspect to the whole.

The rectangular edifice at nearly the center of the picture is the "Septizonium," a seven-story building, as its name indicates; the object of which has never been known. There was another story in the time of Pope Sextus V, and during that era there was an engraving made of it, which we now possess, and which is of very great service in the restoration of the building.

In the upper part are the surrounding walls of the Palace of the Caesars; a little further to the left is the residence of Augustus and the theater of that Emperor. From there, by a subterranean passage, he was able to reach his box, where the statue of Rome was located.

This restoration has been made in accordance with a plan of Ancient Rome, which was engraved on the stone pavement of a temple, and which has been conveyed to the

Capitol; accordingly, there is an absolute fidelity both as to the location of the different monuments, and also, which is equally important, in regard to the dimensions, for it must be understood that the Circus would hold 150,000 spectators.

The Romans were passionately fond of the races; and the Circus had become just as much of a necessity to the multitude as food. One might well inscribe on this picture, as its epigraph, the verses of Horace:

"There are who joy them in the Olympic strife
And love the dust they gather in the course;
The goal by hot wheels shunn'd, the famous prize,
Exalt them to the gods that rule mankind."[16]

The painting seems uncannily cinematic in conception: It has vast scale; its head-on view of the horses about to make a difficult turn involves the viewer dramatically; and it convincingly depicts the sweep of the famed classical site. The low viewpoint and long perspective into the circus give an immediacy to the crisply painted, surging teams and their drivers. To modern eyes, the most jarring note about the horses is the misrepresentation of their gait, with both front legs shown extended in what we know to be a physiological impossibility. It was only in 1878 that the American photographer Eadweard Muybridge successfully took sequential photographs of a galloping horse (fig. 10). This scientific demonstration was announced in Paris in *La Nature* in December 1878 and

FIGURE 10. Eadweard Muybridge (American, 1830–1904). Illustration from *Animal Locomotion* (Philadelphia, 1887), pl. 634. It was only in 1878 that Muybridge successfully took photographs of a galloping horse. His work revealed the physiological impossibility of the gait of the horses as seen in *The Chariot Race* (figs. 1 and 9).

FIGURE 11. *Circus Maximus*. Engraving from Luigi Canina, *L'architettura antica* (Rome, 1831–44), pt. 3, vol. 3, pl. 136. As an erudite man, Gérôme read classical languages and was familiar with works on this period. This book, along with Charles Dezobry's *Rome au siècle d'Auguste*, may have provided a direct source for Gérôme's overall composition in *The Chariot Race* (figs. 1 and 9).

in 1881, when Muybridge himself showed slides to a group of artists at Meissonier's house, with Bonnat, Degas, Gérôme, and Moreau among the guests.[17]

One can, however, question the archeological exactness of this painting. While Gérôme's *Hail Caesar! We Who Are About to Die Salute You* (Yale University Art Gallery), for example, is set in the still-standing Colosseum, the Circus Maximus was all but non-existent. Thus, Gérôme would have had to base his conception on literary sources (he read Latin and Greek), on ancient visual representations such as the images on cameos, and on the fairly recent archeological work he might have seen in progress during his sojourn in Rome in the 1840s. Throughout the nineteenth century, the architectural antiquities of Italy and Greece were being published, as Germany, France, Great Britain, and the United States established archeological academies in Rome and Athens to document the classical past. These publications are both more scientific in their technique and more speculative in their reconstructive imagery than similar volumes by their eighteenth-century predecessors, such as James Stuart and Nicholas Revett. To acquire, as Gérôme did, copies of ancient armor, cast from extant originals, was one thing. To reconstruct from the most fragmentary foundations the largest structure in ancient Rome was quite another.

A plate from Luigi Canina's *L'architettura antica* (Rome, 1840) (fig. 11) has been mentioned as a direct source for Gérôme's overall composition,[18] as has Charles Dezobry's *Rome au siècle d'Auguste* (Paris, 1846), a book that Gérôme cited in arguing for the authenticity of his 1872 painting *Pollice Verso* (Phoenix Art Museum).[19] All of Gérôme's "reconstructed" buildings

in *The Chariot Race* are more or less defensible, save for the tall edifice in the center background, which was perhaps depicted erroneously with seven stories because its name, the Septizonium, was misinterpreted.[20] James also recorded that the architect and theoretican Eugène Emmanuel Viollet-le-Duc helped Gérôme with the architectural detail of this painting.[21]

A small oil sketch for this work exists (fig. 12), as do two drawings for the horses in the chariot teams (see fig. 13).[22] Gérôme reused and recycled details and themes throughout his career, but such direct preparatory materials are rare for him. The chief alteration between the sketch and finished work is the rotation of the horses from a position parallel with the picture plane to a more frontal orientation in the finished panel. Consequently, the horses seem to erupt from the depths of pictorial space, to charge directly at the observer. This can be compared with Manet's 1864 *Races at Longchamps* (fig. 14), which offers a more focused confrontation with the on-coming horses. In Manet's composition, the viewer is placed in the path of the race, while Gérôme creates a similar effect through his panoramic setting. We know that Gérôme had some influence on Manet,[23] and it is evident that he was aware of Manet's compositional innovation in *Races at Longchamps* as Gérôme refined *The Chariot Race* in the 1860s.

The most problematic painting by Gérôme in the Art Institute is the work now known as *Love the Conqueror* (fig. 15), first exhibited at the Salon of 1889 under the title *Whoever You Be, Here Is Your Master. He Is, He Was, or He Should Be.*[24] This quotation, unattributed in the Salon catalogue, is from Voltaire,[25] and is variously described as having been an inscription for a statue of

FIGURE 12. Jean Léon Gérôme. *Circus Maximus*, mid-1860s. Oil on canvas, 16.1 × 32.3 cm. Liverpool, Walker Art Gallery.

FIGURE 13. Jean Léon Gérôme. *Horse* (study for *The Chariot Race*), before 1876. Black chalk on paper; 11 × 14 cm. Vesoul, Musée. Photo: *Gérôme* (Vesoul, 1981), p. 77.

FIGURE 14. Edouard Manet (French, 1832–1883). *The Races at Longchamps*, 1864. Oil on canvas; 43.9 × 84.5 cm. The Art Institute of Chicago, Potter Palmer Collection (1922.424). Manet's innovative composition involves the viewer by placing him directly in the path of the race. Aware of Manet's achievement in this painting, Gérôme also placed the viewer in the path of the chariot race, in a wide screen setting.

Cupid located in the gardens or bedroom at the chateau at Cirey, the home Voltaire shared with Madame du Châtelet from 1739 to her death in 1749, or in the gardens at Sceaux, a seventeenth-century chateau belonging to Voltaire's patroness the Duchesse du Maine.[26] The quotation seems to have been widely known in Gérôme's time and reflects a common enough sentiment; Balzac referred to it in the opening of *Père Goriot*.[27] Although Gérôme read the classical languages, it is most likely that his reference was to Voltaire rather than to the ultimate source, the so-called *Greek Anthology*.[28]

What does this painting mean? There appears to have been a paucity of comment on it when it was executed. For example, it was given a double-page reproduction in the lavish *Figaro-Salon* by Albert Wolff, but it is not mentioned in the text. Wolff did mention the painting in the daily *Figaro* (Apr. 30, 1889):

Here we are in front of the painting by Gérôme, *Love the Conqueror*. In this work, we are immersed in complete fantasy, because in reality, lions and tigers would throw themselves on this succulent child, and not just give him a kiss. However, I am not among those who wish to limit all works of art to the same formula; I fully understand that

purely imaginary scenes have their place, providing that the artist creates them, as does Gérôme, with the utmost knowledge, care, and talent.[29]

All of this does not say very much. What we do know is that Gérôme in the 1880s and 1890s produced a number of paintings that combined obsessive realism with figures of the imagination, creating fleshy personifications of ideals and attributes of mind, such as *The Poet's Dream* (1885, now lost).[30] *Love the Conqueror*, done nearly forty years after the portrait of Mme Faivre, displays the same superb technique of the earlier picture; the depiction of the animal's fur is as brilliant as that on the sleeves of Mme Faivre's coat. The animals are modeled with geometric precision, a result of Gérôme's careful studies sketched in Paris's great public zoo in the Jardin des Plantes.

A photograph taken in Gérôme's studio shows the Art Institute painting on the easel (fig. 16), and a number of studies for individual animals in the composition, presumably made in the Jardin des Plantes.[31] The photograph also reveals Gérôme's method of working, as confirmed by several of his students: He finished his compositions area by area, figure by figure, filling in the

FIGURE 15. Jean Léon Gérôme. *Love the Con-*
queror, 1889. Oil on canvas; 98.5 × 159 cm. The
Art Institute of Chicago, George F. Harding Col-
lection (1983.379). The meaning of this painting
seems to have been unclear to Gérôme's contempo-
raries and remains so today. In addition, its in-
tensely materialistic presentation of an abstract
concept makes a rather bizarre impression on the
viewer.

background at the end. In the center of the finished
picture, a pentimento is visible; apparently there was, at
one time, another beast between the groups at the left
and at the right.

The Jardin des Plantes was heavily used by artists of
many different stripes to study the wild animals. The
animalier sculptors took much of their material from the
inhabitants of the zoo; no less a painter than Eugène
Delacroix did animal studies there. In his late *Lion Hunt*
(fig. 17), the romantic Delacroix provided a view of
human-animal interaction that is very different from
Gérôme's. Despite a certain distance from the viewer in

Delacroix's composition, the force and dynamism of his
scene of imagined struggle contrast strongly with
Gérôme's rather airless assembly of sketches from life.

It is clear that Gérôme had an understanding of the
great felines in his painting. They are each portrayed
with great sympathy, but relationships between them are
lacking. Although the figure of Cupid is the apparent
focus of the animals' attention, the confrontation of the
embodied and the ideal is not convincing. Love, person-
ified by a flesh-and-blood child with the classical at-
tributes of the wings and bow, is literally juxtaposed, in a
harsh wooden cage in which we are also present, with a
congeries of individually observed beasts. Gérôme has a
direct and unique vision, here illustrating a common
proverb while drawing on his repertory of sketches from
nature, but the painting fails to totally engage the viewer
because Gérôme could not translate a psychological
truth into a literal reality.

Thus far, we have considered Gérôme as a painter,
which he was exclusively until some time in the
mid-1870s. Although there is some evidence that he had

FIGURE 16. Jean Léon Gérôme in his studio, Paris, c. 1889. Photo: courtesy of Yale University Art and Architecture Library, Slide and Photograph Collection. The photograph shows the artist in the act of painting *Love the Conqueror* (fig. 15).

FIGURE 17. Eugène Delacroix (1798–1863). *The Lion Hunt*, 1861. Oil on canvas; 76.5 × 98.5 cm. The Art Institute of Chicago, Potter Palmer Collection (1922.404). A comparison with *Love the Conqueror* (fig. 15) reveals the tremendous contrast between Delacroix's depiction of animals and that of Gérôme, even though both did studies in the Jardin des Plantes. The ferocity and power of Delacroix's lions, reinforced by his bravura brushwork, exemplify this Romantic artist's approach to subjects and style. Gérôme's tame domestic cats, however, are captured in tight strokes that reveal the Salon artist's meticulous approach to painting.

FIGURE 18. Jean Léon Gérôme. *Anacreon, Bacchus, and Cupid*, 1848. Oil on canvas, 134 × 203 cm. Toulouse, Musée des Augustins.

modeled small figures as studies for paintings as early as the 1850s,[32] it was only in the 1870s that he began to sculpt as a major mode of expression. Gérôme made his public debut as a sculptor with an ambitious piece in the 1878 Exposition Universelle, *The Gladiators* (Paris, Musée d'Orsay; later altered), based on figures in his painting *Pollice Verso* of 1872; he followed this with *Anacreon, Eros, and Bacchus* of 1878–81. The theme of Anacreon runs throughout Gérôme's work, from his early painting of *Anacreon, Bacchus, and Cupid* of 1848 (fig. 18), and includes a sculpture of the same subject now in the Art Institute (fig. 19).[33] Our knowledge of the life and work of Anacreon, a lyric poet born c. 570 B.C. in Teos, a Greek city in Asia Minor, is very vague. He died at an advanced age, and his poetry is known only in scattered fragments. Gérôme's most important source on Ana-

creon would have been a collection in the style of the poet dating to perhaps the second century A.D., called the *Odes of Anacreon* or the *Anacreontea*. These slight poems are concerned, as apparently was the poet himself, with wine, women, and song, and with the lamenting of the advance of age. Another source would have been the *Greek Anthology*. Both these titles were widely popular in France from the seventeenth through the end of the nineteenth centuries, and were constantly in print in many editions.[34] With his linguistic skills, Gérôme could have garnered his knowledge of the poet from works in the original language, or from French translations and commentaries.

The original of the Art Institute's piece was executed by Gérôme in plaster and exhibited at the Salon of 1881. The first work in permanent material created from the exhibited plaster seems to be a life-sized marble in Copenhagen; casts and reductions of several sizes in bronze are known, the Art Institute's example being the second largest.[35] The piece recalls clearly the tipsy figure

of the poet in Gérôme's painting of three decades before. A drawing of the aged bard's face (fig. 20) done for that picture bears close resemblance to the sculpted version. A more direct source for both the earlier painting and the later sculpture and other paintings are the illustrations by Anne Louis Girodet-Trioson of a book of poems, *Anacréon, Recueil des compositions desinées par Girodet et gravées par M. Chatillon* (Paris, 1825). There are several possible classical sources: we know that Gérôme took great interest in the archeological discoveries of his day, such as the terracotta figures from Tanagra, first excavated in the 1870s, and the Praxitelean *Hermes and the Infant Dionysus*, excavated at Olympia in 1877 and immediately made known through photographs. Perhaps the most direct source, however, is a bronze by James Pradier of 1844–45 (fig. 21), which Gérôme would have seen at the Salon of 1846. But, unlike the rather fussy character of Pradier's piece, that of Gérôme's sculpture is restrained and clearly classicizing, even more so than in his 1849 painting. Anacreon's drapery is clearly and intentionally classical, reflecting the idealized wet-drapery style of the Athenian sculptor Phidias.

The marble in Copenhagen was worked up by professional technicians from Gérôme's plaster, and the bronze edition was made by professional founders, in this case the Parisian firm of Barbédienne, which presented this cast to the Art Institute in 1893. There is no evidence that this piece was exhibited at the World's Columbian Exposition, although two canvases by Gérôme, lent by American collectors, and a tinted, life-sized marble of *Pygmalion and Galatea*, then in the Yerkes Collection in Chicago and now at San Simeon, were on view. More likely, Barbédienne used the occasion of the Exposition and the opening of the museum's new building to ingratiate his firm with the Art Institute in hopes of future sales.

The second sculpture by Gérôme in Chicago, *Napoleon Entering Cairo* (fig. 22), dates to 1897.[36] By this time, Gérôme had switched to the firm of Siot-Decauville for casting his works, and this is a richly detailed, gilded example of their fine workmanship. The piece, first in a series by Gérôme of equestrian portrayals of famous military leaders—*Tamerlane* (Salon of 1898), *Frederick the Great* (Salon of 1899), *Caesar Crossing the Rubicon* (c. 1900), and *Washington* (Salon of 1901)—was a success at the Salon of 1897, where it was purchased by the French state for 10,000 francs. Gérôme declined an offer of twice that from a private collector,

FIGURE 19. Jean Léon Gérôme. *Anacreon with the Infants Bacchus and Cupid*, 1878–81. Bronze; h. 74 cm. The Art Institute of Chicago, presented by G. L. B. Barbédienne (1893.287).

FIGURE 20. Jean Léon Gérôme. *Anacreon*, c. 1848. Black chalk on paper; 19.5 × 10 cm. Nancy, Musée des Beaux-Arts. Photo: *Gérôme* (Vesoul, 1981), p. 40.

depicted the emperor in numerous paintings, usually with Egyptian settings, as well as in several sculptures.[38] Even under the Third Republic, tension between monarchists, Bonapartists, and republicans continued to the end of the century. As time passed, works of art featuring Napoleon had political meaning and a broader appeal as symbols of the military glory of the nation, particularly after the Franco-Prussian War.

In *Napoleon Entering Cairo*, Gérôme showed the young general making his triumphal entry into the Egyptian capital on July 24, 1798, after his victory in the Battle of the Pyramids. The small bronze is a tour de force of detail: the rider's costume, the orientalizing dec-

FIGURE 21. James Pradier (Swiss, 1790–1852). *Anacreon and Cupid*, 1844–45. Bronze; h. 75 cm. Geneva, Musée d'Art et d'Histoire.

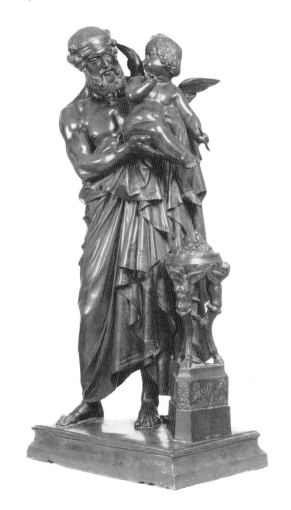

but retained rights to make reproductions, a most unusual arrangement for a purchase by the state.[37]

Napoleon's hold over the French imagination was powerful and of long duration, beginning with his early victories in Italy, and lasting through the Consulate, the Empire, the Restoration, the July Monarchy, and the Second Empire. Gérôme, a luminary of the Second Empire, must have known of the magnificent ceremonies marking the return of the emperor's body from St. Helena and its interment in Les Invalides, Paris, in December 1840, since he had arrived in the capital from Vesoul only two months previously. During the regime of Napoleon's nephew Louis Napoleon, first as prince-president and then as emperor, the founder of the first empire was obviously in vogue. Gérôme, who kept a cast of Napoleon's death mask in his studio (see fig. 2),

172

oration of the horse furniture, and the anatomy of the splendid Arabian animal itself are superbly depicted. The saddle and other equestrian equipment are exacting copies of the Mameluk furnishings French officers affected during the Egyptian campaign. Gérôme, an avid horseman, probably had first-hand knowledge of these kinds of objects from his trips to Egypt or from the militaria collection of his colleague, the painter Edouard Detaille, which is today in the Musée de l'Armée in Paris.[39] Resonances between the young conqueror of the Mameluk dynasty riding a leaf-strewn path into the ancient city and Gérôme's painting *Entry of Christ into Jerusalem* (Vesoul, Musée), shown in the same Salon,[40] would have been apparent to contemporary viewers. *Bonaparte Entering Cairo* was very well received critically,[41] and is perhaps the most successful of Gérôme's equestrian series; it also did well commercially, selling at Tiffany's in limited editions.

In the revival of interest and re-examination of French Salon artists that has taken place in the past two decades, Gérôme has assumed a leading place. His art is precise and exact—in a word, intellectual. But it lacks emotional engagement and the concomitant excitement of color. Gérôme's is an exacting art, but its mastery is that of a closed order, an end, not a beginning. As one early critic put it:

Gérôme is a severe and comprehensive student of history and life, and he introduces to us the varied phases of this tragic and ironical drama made up of laughter and tears, of superstition and scepticism, and he makes us wonder, and detest and reverence the vanishing generations of men, their art, their science, their actions; he is fully equipped; he draws from the past and the present; but Corot, simple Corot, a mere landscape painter, by the freshness and force of his talent and genuine love of nature, with his little work can in a moment make us forget the cruel Roman, the sparkling pleasure-loving Greek, the sullen Turk and the austere Arab of Gérôme's masterly works.[42]

This is a fair and perceptive assessment of Gérôme's historical paintings. At this distance, however, we can appreciate his strengths in painting and sculpture in their own terms, not simply as inferior to works by Corot or Manet or Rodin. In his painting, and particularly in his sculpture, Gérôme's industry became art.

Today, a century after he was *hors concours* at the Exposition Universelle of 1889, we hang Gérôme in the galleries again. After decades of obscurity, his paintings

FIGURE 22. Jean Léon Gérôme. *Napoleon Entering Cairo*, 1897. Gilt bronze; h. 41 cm. The Art Institute of Chicago (1988.36.8). The subject of this sculpture underscores Napoleon's powerful hold over the French imagination.

are now in the company of the contemporary works of the Impressionists and Post-Impressionists. In the past two decades, there has been reappraisal of the academic art of what has been called "the other nineteenth century,"[43] stemming from the realization that there were multiple strands of art activity operating simultaneously with similar or radically different values, goals, and audiences. This re-evaluation has to do with the tides of time and taste, the art market, and the engine of academic art history. To proclaim multiplicity, as does the recall of these long-ignored works from museum storerooms to gallery walls, is not to deny the values of any particular school, fashion, or style, but to recognize that the bourgeois society created by nationalism and industrialism in the course of the century after 1789 was in fact more elastic and capacious culturally than we had formerly realized. Just as the social historians of art Jules and Edmond Goncourt in the 1850s and 1860s could rediscover and rehabilitate the Rococo of Louis XV, a century after the ferment of the dynamic Third Republic, we are able to see more clearly the various facets of the art of that time in Paris, and to appreciate the values of each.

NOTES

Pemberton, "Art and Rituals for Yoruba Sacred Kings," pp. 97–111.

This essay is based upon a Fry Foundation Lecture presented at The Art Institute of Chicago on May 13, 1986. The author is grateful to Dr. Richard Townsend, Curator, Africa, Oceania, and the Americas, for the invitation to participate in the Fry Lecture Series. The data for this essay was gathered during numerous research trips over the past seventeen years to the Igbomina and Ekiti areas of the Yoruba. The author is indebted to His Highness, Oba William Adetona Ayeni, Ila-Orangun, for his permission to pursue research in Ila-Orangun, and to Chief Odoode for his information regarding the myths and rituals associated with the *Oro* festival in Ila. Funding for the study of this festival was received from the National Endowment for the Humanities and the National Geographic Society, and was carried out on sabbatical leaves in 1981 and 1984 from Amherst College, Amherst, Massachusetts.

1. On the art of ancient Ife, see Frank Willett, *Ife in the History of West African Sculpture* (New York, 1967); and Ekpo Eyo and Willet, *Treasures of Ancient Nigeria* (New York, 1980).

2. The discussion of Yoruba aesthetic concepts in the article is indebted to Rowland Abiodun, "Identity and the Artistic Process in Yoruba Aesthetic Concept of *Iwa*," *Journal of Cultures and Ideas* 1, 1 (1983), pp. 13–30; and idem, conversation with the author, Sept. 1987.

3. William Fagg and M. Plass, *African Sculpture: An Anthology* (New York, 1964), p. 90.

4. Fagg, "The African Artist," in *Tradition and Creativity in Tribal Art*, ed. D. Biebuyck (Berkeley, 1969), p. 54.

5. Fagg (note 4), p. 55.

6. Personal communication from Chief Sao, Ikere Ekiti, June 9, 1988.

7. Fagg (note 4), p. 56.

8. An analysis of the festival for the king was previously published in John Pemberton III, "Festivals and Sacred Kingship among the Igbomina Yoruba," *National Geographic Research* 2 (1986), pp. 216–33.

9. H. J. and M. T. Drewal, *Gelede: Art and Female Power Among the Yoruba* (Bloomington, Ind., 1983).

Wolff, "An Image of Compassion: Dieric Bouts's *Sorrowing Madonna*," pp. 113–25.

1. The painting was in the Williams collection, Paris, by 1871, and was sold to Joseph Spiridon, Paris, in 1889. Baron Joseph van der Elst bought the work at the Spiridon sale, Berlin, Cassirer and Helbing, on May 31, 1929, no. 71; it stayed in his family until it was acquired by the Art Institute from Richard J. Collins, Inc., New York.

The painting originally had an engaged frame, as is indicated by the raised lip of paint and the margins of unpainted wood on all sides. While the paint surface is, in general, in very good condition, there is some abrasion, particularly in the white wimple and in the gold background.

2. His will bears that date, and the inscription on an epitaph portrait, now lost, has been interpreted to mean that he died on May 6, 1475. See Wolfgang Schöne, *Dieric Bouts und seine schule* (Leipzig and Berlin, 1938), pp. 1–3, and docs. 17 and 92, pp. 230–32 and 249.

3. The surviving versions are enumerated in Schöne (note 2), no. 19, pp. 129–32 and the list updated by Colin Eisler, *Primitifs flamands. Corpus. New England Museums* (Brussels, 1961), pp. 59–61, and by Hélène Adhémar, *Primitifs flamands. Corpus. Le Musée National du Louvre*, vol. 1 (Brussels, 1962), pp. 57–59.

4. This manner of depicting Moses arose from a mistranslation of the biblical account of his appearance after he received the tablets of the law; see Louis Réau, *Iconographie de l'art chrétien*, vol. 1, pt. 1 (Paris, 1956), pp. 176–78.

5. Ms. 2, f. 26v.; ill. Millard Meiss, *French Painting in the Time of Jean de Berry. The Boucicaut Master* (London, 1968), fig. 12.

6. See the excellent summary of Sixten Ringbom, *Icon to Narrative: The Rise of the Dramatic Close-up in Fifteenth-Century Devotional Painting* (Åbo, 1965), esp. pp. 11–22.

7. Ringbom (note 6), pp. 39–46, emphasized the connection of half-length devotional images to portraiture, particularly in the royal or noble associations that may be conveyed by the appearance of the holy figures in a windowlike opening behind a parapet.

8. Erwin Panofsky, *Early Netherlandish Painting: Its Origins and Character* (Cambridge, Mass., 1953), pp. 294–97.

9. That these two paintings once formed a diptych was demonstrated by Georges Hulin de Loo, "Diptychs by Rogier van der Weyden," *Burlington Magazine* 43 (Aug. 1923), pp. 57–58. For Philippe de Croy, see further Lorne Campbell, *Van der Weyden* (New York, 1980), pp. 85–86. For the abstracted gaze of the donor indicating visionary rather than actual sight, see James Snyder, "Jan van Eyck and the Madonna of Chancellor Nicolas Rolin," *Oud-Holland* 82 (1967), pp. 165–66.

10. Jan Białostocki pointed out a number of instances in which Memling used the spatial surround to imply an extension of the picture space into the viewer's space; see "Modes of Reality and Representation of Space in Memling's Donor Wings of the *Last Judgment* Triptych," in *Essays in Northern European Art Presented to Egbert Haverkamp-Begemann on his Sixtieth Birthday* (Doornspijk, 1983), pp. 38–42.

11. Ringbom (note 6), pp. 66–71.

12. Ibid., pp. 69–71; and Otto Pächt, "The 'Avignon Diptych' and Its Eastern Ancestry," in *De Artibus Opuscula XL. Essays in Honor of Erwin Panofsky*, ed. Millard Meiss (New York, 1961), pp. 405–407.

13. For the Eyckian versions of the Holy Face, see Max J. Friedländer, *Early Netherlandish Painting*, vol. 1 (rev. ed. 1967), pp. 68–69, pl. 63; and Elisabeth Dhanens, *Hubert and Jan van Eyck* (Antwerp, 1980), p. 293, figs. 181, 183.

14. Pächt (note 12), pp. 402–21.

15. Ringbom (note 6), pp. 66–69; and H. W. van Os, "The Discovery of an Early Man of Sorrows on a Dominican Triptych," *Journal of the Warburg and Courtauld Institutes* 41 (1978), pp. 65–75, esp. pp. 70–75.

16. Erwin Panofsky, "Jean Hey's 'Ecce Homo': Speculations about its Author, its Donor, and its Iconography," *Bulletin des Musées Royaux des Beaux-Arts de Belgique* 5 (1956), p. 112, pointed out this innovation, while considering that the image is "not unequivocally connected" with Saint John's account. For the innovative character of Bouts's diptych pairing, see Karl Arndt, "Zum Werk des Hugo van der Goes," *Münchner Jahrbuch der bildenden Kunst* 15 (1964), pp. 74–75, 95.

17. The best version is in the Museum Boymans-van Beuningen, Rotterdam; Friedländer, *Early Netherlandish Painting*, vol. 3 (rev. ed. 1968), pp. 67 and 76, no. Add. 119, pl. 74.

18. Otto G. von Simson, "*Compassio* and *Co-Redemptio* in Roger van der Weyden's *Descent from the Cross*," *The Art Bulletin* 35 (1953), pp. 9–16.

19. See p. 113 and note 2 above.

20. In his 1938 monograph (note 2), Schöne attributed some paintings given to Bouts himself in Friedländer's corpus (note 17) to Dieric Bouts the Younger, whom he identified as the painter of the so-called *Pearl of Brabant* triptych in the Alte Pinakothek, Munich, and to a painter he called the Master of the Munich *Taking of Christ*, named after two altarpiece wings in the same museum. In addition to these attributions, based on style, the work of Bouts's second son, Aelbert, can be readily identified. See Jacqueline Folie, "Les Oeuvres authentifiées des primitifs flamands," *Bulletin de l'Institut royal du patrimoine artistique* 6 (1963), pp. 249–51. Schöne's attributions have only found partial acceptance; see the summary of more recent literature in Friedländer (note 17), pp. 80–81.

21. See Folie (note 20), pp. 216–17.

22. See Schöne (note 2), pp. 108–15, no. 13; and Lucie Ninane, "Un Chef-d'oeuvre de Thierry Bouts aux Musées royaux," *Bulletin des Musées royaux des Beaux-Arts de Belgique* 6 (1957), pp. 15–38. Payments for the movement of panels between the town hall and Bouts's studio indicate that *The Ordeal by Fire* must have been executed c. 1470–73; see Schöne (note 2), pp. 243–44, docs. 69 and 71. A settlement with Bouts's heirs in 1480 for the work commissioned for the town hall indicates that one panel was finished and another almost finished and that a triptych of the Last Judgment was also executed for the town hall. Paintings of *Heaven* and *Hell* now in Lille are usually identified as the wings of the *Last Judgment*; Friedländer (note 17), pp. 21, 63, 81, 87, n. 38, pls. 46–47, nos. 30–31.

For the way the physical state of the panels confirms the documentary record, see Paul Philippot, "A Propos de la 'Justice d'Othon' de Thierry Bouts," *Bulletin des Musées royaux des Beaux-Arts de Belgique* 6 (1957), pp. 55–80, with numerous detail photographs.

23. Friedländer (note 17), pp. 27, 61, pl. 20, no. 12.

24. Ludwig Baldass, "Drei Jahrhunderte flämische Malerei," *Pantheon* 5 (1930), p. 132, and "Die Entwicklung des Dirk Bouts," *Jahrbuch der Kunsthistorischen Sammlungen in Wien*, N.F. 6 (1932), pp. 86, 114; Friedrich Winkler, "Dieric Bouts und Joos van Gent Ausstellungen in Brüssel und Gent," *Kunstchronik* 11 (1958), p. 5 and Pächt (note 12), p. 404. Friedländer listed the painting as a replica in *Die Altniederländische Malerei*, vol. 3 (Berlin, 1925), p. 124, no. 83; but promoted it to the finest version of the series in his addendum, vol. 14 (Leiden, 1939), p. 91; see also idem. (note 17), pp. 71, 88, n. 67, no. 83f.

See also Gustav Glück, "Drei Jahrhunderte flämische Kunst, Ausstellung in der Wiener 'Secession'," *Belvedere* 9 (1930), p. 78; Brussels, Palais des Beaux-Arts, and Delft, Museum 'het Prinsenhof', Delft, *Dieric Bouts*, exh. cat. (1957/1958), no. 24; and Frans Baudouin, "Kanttekeningen bij de Catalogus van de Dieric Bouts-Tentoonstelling," *Bulletin des Musées royaux des Beaux-Arts de Belgique* 7 (1958), p. 139.

25. Schöne (note 2), pp. 131–33.

26. Schöne (note 2) placed it as early as 1450; see also Baldass (note 24), pp. 86, 114.

27. The results of such a survey will be published, along with other information, in the forthcoming catalogue of German, Netherlandish, French, and Spanish painting from 1400–1600 in the collection of the Art Institute.

28. Ill. Friedländer (note 17), pl. 27.

29. For the Granada triptych, see Friedländer (note 17), pls. 3 and 4; and Roger van Schoute, *Primitifs flamands. Corpus. La Chapelle royale de Grenade* (Brussels, 1963), pls. 41–74. For the Mary altarpiece and the Madonnas in San Francisco, New York, and Florence, see Friedländer (note 17), nos. 1, Add. 115, 9c, and 9, and pls. 1, 2, 17, and 125, respectively.

Siegfried: "Boilly's *Moving House*: 'An Exact Picture of Paris'?," pp. 127–37.

This is a revised version of an article written for the forthcoming publication *Tableaux de Paris: Art and Culture in France, 1750–1950*, eds. Leila W. Kinney, Michael Marrinan, and Molly Nesbit, and is used here with the permission of the editors and Yale University Press. I would like to thank The Art Institute of Chicago for its generous support of my work on Boilly, which was undertaken in preparation for an exhibition of paintings and drawings by the artist. It should also be noted that the French title of Boilly's painting in the collection of The Art Institute of Chicago, *Les Déménagements*, is untranslatable. The English titles used in this article were arrived at with the approval of the curator and are consistent with the journal's policy of translating foreign language phrases and titles of works of art.

1. Michel N. Benisovitch, "Une Autobiographie du peintre Louis Boilly," *Essays in Honor of Hans Tietze, 1880–1954* (Paris, 1950–58), p. 372.

2. Cited in Paul Marmottan, *Le Peintre Louis Boilly (1761–1845), ouvrage orné de 72 planches et figures* (Paris, 1913), p. 157.

3. Archives de Paris, Côte D. 48E³ 23.

4. New York, Wildenstein Gallery, *Consulat-Empire-Restoration: Art in Early XIX Century France* (1982), pp. 87–88.

5. John Stephen Hallam, *The Genre Works of Louis-Léopold Boilly* (Ann Arbor, 1979), p. 112; Joseph Ballio in Wildenstein

Gallery (note 4), pp. 87–88; and Carol S. Eliel, *Form and Content in the Genre Works of Louis-Léopold Boilly* (Ann Arbor, 1985), p. 44.

6. Eliel (note 5), p. 43.

7. Hallam (note 5), pp. 113–14.

8. The standard sources for factual information and documents about Boilly's life are Henri Harrisse, *L. L. Boilly, peintre, dessinateur et lithographe; sa vie et son oeuvre, 1761–1845* (Paris, 1898), pp. 1–45 passim; Marmottan (note 2), pp. 255–77; and Jean de la Monneraye, "Documents sur la vie du peintre Louis Boilly pendant la Révolution," *Bulletin de la Société de l'histoire de l'art français* (1929), pp. 15–30.

9. Boilly's first biographer, who availed himself of this myth, set the tone for later scholars; see Arthur Dinaux, "Boilly," *Archives historiques et littéraires du nord de la France et du midi de la Belgique* 6, n.s. (May 1849), pp. 194–209.

10. See Harrisse (note 8); and Marmottan (note 2).

11. From the recent literature on Boilly, see: Hallam (note 5), and idem, "The Two Manners of Louis-Léopold Boilly and French Genre Painting in Transition," *The Art Bulletin* 63 (1981), pp. 618–33; George Levitine, "Boilly's Two Manners," *The Art Bulletin* 64 (1982), pp. 320–21; Yves Brayer, "Louis Boilly, Chroniqueur de son temps"; and "Louis Boilly, Précurseur de l'esthétique moderne," in Paris, Musée Marmottan, *Louis Boilly, 1761–1845*, pp. 5–9, 11–18; Eliel, "Louis-Léopold Boilly's 'The galleries of the Palais Royal,'" *The Burlington Magazine* 126, 974 (May 1984), pp. 275–79; and Eliel (note 5). For a critique, see Richard Wrigley, "Boilly at the Musée Marmottan," *The Burlington Magazine* 126, 976 (July 1984), pp. 453–54.

12. See René Musnier, *Les Messageries nationales* (Paris, 1849); André Blum, *Histoire du costume: Les Modes au XVIIᵉ et XVIIIᵉ siècle* (Paris, 1928); André Blum and Charles Chassé, *Histoire du costume: Les Modes au XIXᵉ siècle* (Paris, 1931); Marcel Reinhard, *Histoire de France*, 2 vols. (Paris, 1954); Jean Tulard, *Nouvelle Histoire de Paris: Le Consulat et l'Empire, 1800–1815* (Paris, 1970); Guy Chaussinaud-Nogaret, "La Ville jacobine et balzacienne," pt. 3 of *La Ville classique*, vol. 3 of *Histoire de la France urbaine*, ed. Georges Duby (Paris, 1981), pp. 537–619, 626–27; 636–37; and Roger Price, *A Social History of Nineteenth-Century France* (London and Melbourne, 1987).

13. Etienne Jean Délécluze, "Beaux-Arts-Exposition. Salon de 1822 (9ᵉ article)," *Le Moniteur universel* 2, 162 (June 11, 1822), p. 824.

14. Boilly wrote, or at least authorized, the description of his painting for the catalogue of a sale of his works, *Catalogue du précieux cabinet de tableaux, des écoles hollandaise, flamande et française de M. Boilly, peintre, et des ouvrages des plus capitaux de cet artiste . . .* , sale cat. (Paris: Salle Lebrun, Apr. 13–14, 1829).

15. Paris, Bibliothèque Nationale, Cabinet des Estampes, S. N. R. Eugène Lami. Some are reproduced in Chaussinaud-Nogaret (note 12), pp. 590–91.

16. Louis Sébastien Mercier, *Le Tableau de Paris*, ed. Jeffrey Kaplow (Paris, 1985), p. 194. Interestingly, in 1815 Etienne de Jouy identified the area that Boilly was to show in his painting as the "dumping ground" for evicted tenants: "the most recalcitrant . . . evicted at the request of the landlord, on the place du Châtelet" ("les plus récalcitrants . . . qu'on a exproprié, à [la] requête [du propriétaire], sur la place du Châtelet"), in *L'Hermite de la Chaussée-d'Antin, ou, Observations sur les moeurs et les usages parisiens au commencement du XIXᵉ siècle* (Paris, 1815), vol. 2, p. 135.

17. Louis Chevalier, *Classes laborieuses et classes dangereuses à Paris, pendant la première moitié du XIXe siècle*, 2d ed. (Paris, 1984), pp. 207–208.

18. The identification of the site in Boilly's painting has been made through comparison with a large watercolor drawing by Louis Nicholas de Lespinasse, inscribed *Third View of the Centre of Paris: View of the Port au Blé taken from the far end of the former Calf Market looking towards the Pont Notre Dame* (1782; Paris, Musée Carnavalet). Though Lespinasse's drawing was probably not a source for Boilly, this large view of the area clearly locates the buildings on the right of *Moving House*. The identification was made by Ballio (note 5), pp. 87–88. On the Port-au-Blé, see Jacques Hillairet, *Dictionnaire historique des rues de Paris*, 3rd ed. (Paris, 1976), vol. 2, pp. 254 and 686. It was not until the mid-1830s that the area around the Port-au-Blé was closed and partly demolished in the wake of a cholera epidemic.

19. Mercier (note 16), p. 196. The emphases are Mercier's.

20. Chevalier (note 17), p. 636.

21. Thérèse Burollet, *Musée Cognacq-Jay, I. Peintures et Dessins* (Paris, 1980), p. 42, no. 9; and Eliel (note 5), pp. 42–44.

22. On Boilly's depiction of Santa Maria del Popolo, see Hallam (note 5), p. 114; and Eliel (note 5), p. 179, n. 77.

23. *L'Observateur et Arlequin aux Salons* (Paris, [1822]), p. 19.

24. Jean Henri Marlet, *Tableaux de Paris* [with texts by V. ". . ." and P. J. S. Duféy de l'Yonne] (Paris, 1821–24), pl. 72. On Marlet's series, see Marlet, *Tableaux de Paris*. [1821–24] 1979. Reprint with commentaries by Guillaume de Bertier de Sauvigny (Paris and Geneva, 1979), pp. 1–2; and Henri René d'Allemagne, *Le Noble Jeu de l'oie en France de 1640 à 1950* (Paris, 1950), pp. 170–72.
Marlet's *Moving House* probably dates from 1823 or 1824. Boilly's Salon painting may have inspired Marlet to include the scene, which had rarely been represented before in paintings or prints.

25. Marlet (note 24), opp. pl. 72.

26. Chevalier (note 17), pp. 614–46; and Daniel Roche, *Le Peuple de Paris: essai sur la culture populaire au XVIIIᵉ siècle* (Paris, 1981), pp. 38–65.

27. Mercier (note 16), p. 197.

28. Ibid., pp. 196–97.

29. The theme of "domesticity in movement" is discussed in *Il progetto domestico: La casa dell' uomo, archetipi e prototipi*, ed. Georges Teyssot (Milan, 1986), vol. 1, pp. 25–27.

30. I differ here with Eliel, who interpreted *Moving House* as a topical response to social concerns of the 1820s; see Eliel (note 5), pp. 42–44.

31. Chevalier's classic study (note 17) is devoted to an in-depth study of these changes.

32. Mercier (note 16), p. 196.

33. Chevalier (note 17), pp. 384–91.

34. Ibid., p. 385.

35. Ibid., pp. 136 and 618–19.

36. Susan L. Siegfried, "Of U-Hauls, Usury, and Louis-Léopold Boilly," *Tableaux de Paris: Art and Culture in France, 1750–1950*, eds. Leila W. Kinney, Michael Marrinan, and Molly Nesbit (New Haven, forthcoming).

37. A. Mabille de Poncheville, *Boilly* (Paris, 1931), p. 156.

Poulet, "A Neoclassical Vase by Clodion," pp. 139–53.

I would like to thank Ian Wardropper, Eloise W. Martin Curator of European Decorative Arts, Sculpture, and Classical Art at The Art Institute of Chicago, for inviting me to give a lecture on this vase to the Antiquarian Society at the Art Institute in December 1988. This article is based on research done for that lecture. I am grateful to Dr. Wardropper for the valuable comments he made about the article. I would also like to acknowledge the suggestions of Jeffrey Munger, Judith Neiswander, and Deborah Weisgall. I should especially like to thank Rachel Dressler for her patience and invaluable help in editing the article.

1. Stella Rubinstein-Bloch, *Catalogue of the Collection of George and Florence Blumenthal*, vol. 5, *Paintings, Drawings, Sculptures: XVIIIth Century* (Paris, 1930), pl. 58. It was exhibited in New York in 1935: New York, The Metropolitan Museum of Art, *French Painting and Sculpture of the XVIIIth Century*, exh. cat. (1935), no. 99, when it was still in the Blumenthal collection.

2. The primary sources for information on the life and art of Clodion are: A. Dingé, *Notice sur M. Clodion* (Paris, 1814); H. Thirion, *Les Adam et Clodion* (Paris, 1885); J. J. Guiffrey, "Le Sculpteur Claude Michel, dit Clodion (1738–1814)," *Gazette des Beaux-Arts*, 3d ser., 8 (1892), pp. 478–95, 9 (1893), pp. 164–76, 392–417; Stanislas Lami, *Dictionnaire des sculpteurs de l'école française au dix-huitième siècle*, vol. 2 (Paris, 1911), pp. 142–59; G. Varenne, "Clodion à Nancy: Ses Années d'enfance; Sa Maison et son atelier de 1793 à 1798," *Revue lorraine illustrée* 3 (1913), pp. 39–57; and New York, the Frick Collection, *Clodion Terracottas in North American Collections*, exh. cat. by Anne L. Poulet (1984).

3. The vase which is signed *CLODION*, is in the collection of Dalva Brothers, Inc., New York. I am grateful to them for permitting me to examine it in detail and to reproduce it in this article.

4. See Alexandre Ananoff, *François Boucher*, vol. 2 (Geneva, 1976), pp. 157–59, fig. 1355, no. 482, for a discussion of the painting of *Vertumnus and Pomona* and its commission as a tapestry design for the king's apartment at Compiègne. The engraving is also reproduced in Ananoff, fig. 1552, no. 574, as is the drawing, fig. 1551, no. 574.

5. *Catalogue Raisonné des Tableaux, Desseins, Estampes, Bronzes, Terres cuites . . . qui composent le Cabinet de feu M. Boucher, Premier Peintre du Roi*, sale cat., Paris, Feb. 18, 1771, p. 33, no.

148: "A vase decorated with a bacchanal of children in low relief and two grotesque masks with rams' horns from which fall garlands of flowers by the same Clodion. Height 9 *pouces*, 6 *lignes*" ("Un vase orné d'un bacchanal d'enfants en bas-relief, & de deux mascarons à cornes de béliers en relief, d'où tombent des guirlandes de fleurs, par le même *Claudion*. Hauteur 9 pouces 6 lignes"). The Dalva vase measures 11.2 inches, while 9 pouces are about 10 inches. Since the description of the Boucher vase corresponds so closely to that in the Dalva collection and to that appearing in Boucher's painting, it would seem that the slight discrepancy in height does not preclude their being identical or at least vases of the same model.

6. Dingé (note 2), pp. 1–2: "They sought out his charming productions, some inspired by the antique, and others by his natural inclination toward an appealing and gracious genre. These works were bought even before they were finished" ("On recherchait ses charmantes productions, les unes inspirées par l'antique, et les autres par ce goût qui lui était naturel pour le genre aimable et gracieux. Elles étaient achetées avant même qu'il les eût finies").

7. For a discussion of this figure, see New York, The Metropolitan Museum of Art, *The Fire and the Talent: A Presentation of French Terracottas*, exh. cat. by Olga Raggio (1976), no. 3; and Poulet (note 2), no. 2.

8. For a discussion of the *Minerva Giustiniani* and its availability to artists for study in the eighteenth century, see Francis Haskell and Nicholas Penny, *Taste and the Antique* (New Haven and London, 1981), pp. 269–71, no. 63. It also seems clear that Clodion knew the *Minerva Ludovisi* as an antique marble figure that was restored by the sculptor Alessandro Algardi in 1627. The soft, girlish features of the head of the Ludovisi figure and the animation and placement of the drapery around the figure's feet are quite close to those of Clodion's *Minerva*. For a discussion of the *Minerva Ludovisi* and its restoration by Algardi, see Jennifer Montagu, *Alessandro Algardi* (New Haven and London, 1985), vol. 1, pp. 12, 14–15, fig. 12; vol. 2, p. 398, fig. 6, no. 115.

9. An illustrated catalogue of the collection was published in Paris in 1755. The title page reads: *Collection des Sculptures antiques Grecques, et Romaines, trouvées à Rome dans les ruines des Palais de Neron, et de Marius. Les Originaux de cette collection en marbre de Paros et Salin sont chez le Sr. Adam l'aîné sculpteur ordinaire du roy, et professeur de son Académie Royale de Peinture et de Sculpture, rue basse du chemin du rempart No. 13. . . .* The first page of the catalogue explains that these sculptures were acquired by Cardinal de Polignac while he was in Rome and were later sent to France. Clodion must have known all of the sculptures in the collection well, including the *Minerva*, which is catalogued as being "two feet high."

10. Dingé (note 2), p. 2, wrote of the great popularity of Clodion's works with collectors from all over Europe who were on the Grand Tour: "French, Italian, English, German, and Russian collectors were eager to commission him. He did much work for the Empress Catherine the Great, who tried without success to lure him to her domain" ("Des amateurs français, italiens, anglais, allemands et russes s'empressèrent de l'occuper. Il travailla beaucoup pour l'impératrice Catherine II, qui tenta, mais en vain, de l'attirer dans ses états").

11. See Guiffrey (note 2), 9 (1893), p. 412. In the inventory of the

contents of Clodion's bedroom are listed "Sixty bound volumes of different sizes, treating different subjects, most of them broken series . . . plus a folio volume, being the third volume of the *Peintures antiques Herculaneum* estimated at 6 francs" ("soixante volumes reliés, de différents formats, traitant de différents sujets, la plupart dépareillés, . . . plus un volume in 8, étant le troisième volume des *Peintures antiques d'Herculaneum*, prisé 6 francs").

12. For an excellent discussion of the popularity and range of interpretations of this subject, see Robert Rosenblum, *Transformations in Late Eighteenth Century Art* (Princeton, 1967), pp. 3–10, figs. 1–5.

13. See Rosenblum (note 12), p. 6.

14. In a letter that Natoire wrote to Marigny on April 16, 1766, he said of Clodion: "M. Clodion, sculptor, has shown me a series of small models which are very fine. This artist demonstrates very good taste in his works and is a very good student" ("Le Sr Claudion, sculpteur, m'a fait voir une suite de petit modelle qui sont fort bien. Cet artiste est remply de goût dans ses ouvrages et fait un très bon sujet"). Published in Anatole de Montaiglon and J. J. Guiffrey eds., *Correspondance des directeurs de l'Académie de France à Rome*, vol. 12 (Paris, 1902), p. 114, no. 5904. It is also interesting to note that Natoire had in his own collection three terracotta sculptures by Clodion. See: Sale catalogue, Collection of Charles Natoire, Paris, December 14, 1778, "Figures and Bas-reliefs: Terracotta" ("Figures et Bas-reliefs en Terre-cuite"), p. 18, no. 75: "Two beautiful figures of vestals, adapted to the antique, by Clodion" ("Deux belles figures de Vestales, ajustées dans le genre antique, par Claudion"), and no. 76. "The Penitent Magdelen, this piece is as perfectly modeled as those preceding, by the same [Clodion]." ("Une Magdaleine Pénitente; ce morceau est aussi parfaitement modelé que les précédens, par le même").

15. For a discussion of Clodion's treatment of the *Selling of Cupids*, see Poulet (note 2), no. 13.

16. Abbé Richard de Saint-Non, *Recueil de griffonis, vues, paysages, fragments antiques . . .* (Paris, [c. 1790]), pl. 20. This album of engravings and aquatints consists of works done by the Abbé and others between 1759 and the early 1770s after antiquities, as well as sixteenth- and seventeenth-century Italian paintings, he had seen in Italy. It is a valuable resource indicating the works of art in Italy that were of interest to an educated French aristocrat in the third quarter of the eighteenth century.

17. It is probable that Saint-Non was copying the terracotta relief rather than a drawing by Clodion, since, to the author's knowledge, no drawing has ever been convincingly attributed to the sculptor.

18. A useful study of Saint-Non and his travels in Italy with the painters Fragonard and Hubert Robert, as well as a list of his publications, can be found in Louis Guimbaud, *Saint Non et Fragonard d'après des documents inédits* (Paris, 1928).

19. For an important study of neo-Attic sculpture, see Werner Fuchs, "Die Vorbilder der Neuattischen Reliefs," *Jahrbuch des Deutschen Archäologischen Instituts* 20 (1959), pp. 171–72. The *Borghese Amphora* is illustrated in pl. 6b; the *Naples Amphora*, now in the Museo Nazionale, Naples, is illustrated in pl. 6a. I would like to thank John Herrmann and Michael Paget of the Classical Department of the Museum of Fine Arts, Boston, for

their helpful suggestions concerning antique prototypes for the Chicago vase.

20. The engraving is found in *Suite de Douze Vases, Composés par Petitot* (Paris, 1764), no. 7, The Metropolitan Museum of Art, New York. For a discussion of and bibliography for the ornamental vase designs of Petitot and his contemporaries, see Rome, Académie de France à Rome, *Piranèse et les français 1740–1790*, exh. cat. (1976), pp. 250–60; and The Baltimore Museum of Art, *Regency to Empire: French Printmaking 1715–1814*, exh. cat. (1984), pp. 182–84, and 355, no. 58.

21. See, for example, the illustration of Michelangelo's figure of Giuliano de' Medici in Howard Hibbard, *Michelangelo* (New York, 1974), p. 186, fig. 125.

22. See John Pope-Hennessy, *Catalogue of Italian Sculpture in the Victoria and Albert Museum* (London, 1964), vol. 1, pp. 70–73; vol. 3, pp. 48–51, figs. 75–77. This relief was formerly owned by Lorenzo de' Medici in Florence.

23. For a discussion of Saly's engravings of vases, see *Piranèse et les français 1740–1790* (note 20), pp. 327–28. I would like to thank Arthur Vershbow for his helpful suggestions concerning the importance of ornamental prints to sculptors and other artists in the mid-eighteenth century. I am also grateful to him and to his wife for their willingness to have their engraving of a vase by Saly reproduced in this article.

24. See Plutarch, *Lives*, trans. by Bernadotte Perrin, *Numa*, 9.4–5. The subject of the cult of Vesta was made popular by French publications such as the Abbé Nadal's *Histoire des Vestales* (Paris, 1725). This book is a collection of lectures given at the Académie Royale des Belles Lettres in Paris and dedicated to the Duc d'Aumont. For a more recent discussion of the cult of Vesta, see B. Cartoux, *Histoire des vestales et de leur culte* (Paris, n.d.). Another important source for artists was Bernard de Montfaucon, *L'Antiquité expliquée et représentée en figures*, 2d ed. vol. 1 (1722) chapter 6, pp. 60–64, pls. 25–27; vol. 2, pt. 1 and v. 2, pt. 1 chap. 8, pp. 30–32.

25. For a brilliant discussion of Vien and the significance of his paintings in the "goût grecque," see Jean Locquin, *La Peinture d'histoire en France de 1747 à 1785* (Paris, 1912; repr. 1978), pp. 190–98, esp. pp. 194–95, figs. 71–72. For Jean Jacques Flipart, see *Regency to Empire: French Printmaking 1715–1814* (note 20), p. 348.

26. Malcolm Warner, "The Sources and Meaning of Reynolds's *Lady Sarah Bunbury Sacrificing to the Graces*," *The Art Institute of Chicago Museum Studies* 15, 1 (1989), pp. 7–19.

27. See Guiffrey (note 2), 9 (1893), p. 412: "Sketch for an offering to Love, in plaster, 1 franc" ("Esquisse d'une Offrande à l'Amour, en plâtre, 1 franc"); p. 413: "Two terracotta bas-reliefs, in their gilded frames, representing the Selling of Cupids, and a Sacrifice to Love, 3 francs" ("Deux terres cuites bas-reliefs, dans leur cadre doré, représentant la Vendeuse d'Amours et un Sacrifice à l'Amour, 3 francs"); p. 415: "A Vestal, same size, making a sacrifice, cast in plaster, 3 francs" ("Une Vestale, même grandeur, faisant le sacrifice, coulée en plâtre, 3 francs").

28. Sale, M. Fortier, Paris, Apr. 2, 1770: "A Vestal crowned with flowers, holding in one hand a vase resting on a tripod, in the other

a *patera*. Statuette in terracotta. Height 13 *pouces*, 6 *lignes*. Signed Clodion Rome 1766" ("Une Vestale couronnée de fleurs, tenant d'une main un vase appuyé sur un trépied, de l'autre une patère. Statuette en terre cuite. Haut, 13 pouces 6 lignes. Signée: *CLODION ROME 1766*"). See Lami (note 2), p. 144. For an excellent survey of other vestals by Clodion, see Cambridge, Mass., Fogg Art Museum; New York, The Metropolitan Museum of Art; and Washington, D.C., The National Gallery of Art, *Fingerprints of the Artist: European Terra-Cotta Sculpture from the Arthur M. Sackler Collections*, exh. cat. by Charles Avery (Cambridge, Mass., 1981), pp. 184–87, nos. 81–82; and Poulet (note 2), pp. 9–11, 13–15, nos. 4, and 6a, b.

29. See Ulrich Middeldorf, *Sculptures from the Samuel H. Kress Collection: European Schools, XIV–XIX Century* (London, 1976), pp. 106–108, fig. 182, no. K1672.

30. For an illustration and discussion of this relief and its location and study in the sixteenth and seventeenth centuries, see Phyllis Pray Bober and Ruth Rubinstein, *Renaissance Artists and Antique Sculpture* (New York, 1986), pp. 230–31, no. 197.

31. There is a French engraving after Raphael's painting by the late seventeenth-century artist Gérard Audran which Clodion could have known. See Grazia Bernini Pezzini, Stefania Masseri, Simonetta Prosperi, and Valenti Rodinò, *Raphael inventit: Stampe da Raffaello nelle collezioni dell'Instituto Nazionale per la Grafica* (Rome, 1985), p. 133, ill. p. 572.

32. Clodion certainly would have studied Raphael's great painting through engravings, before going to Rome, and the painting itself, once he was at the Académie. Many engravings of the whole composition, as well as at least one of this foreground figure, would have been available to him. See Pezzini et al. (note 31), pp. 177–81, ill. pp. 680–84, esp. p. 181, fig. 19, ill. p. 684.

33. The drawing is by Jean Honoré Fragonard. It can be found in Saint-Non (note 16), pl. 20. Dated 1771, the plate is inscribed "by Raphael, painting of the transfiguration in Rome, Church of St. Peter in Montorio" ("de Raphael, tableau de la transfiguration à Rome Eglise de San Pietre [sic] in Montorio").

34. For a list of engravings after *The Fire in the Borgo* see Pezzini et al. (note 31), pp. 54–56, ills. pp. 333, 336; and for the engraving of *Seated Woman with a Vase*, see p. 269, ill. p. 853.

35. The vase is signed and dated on its lip: *CLODION IN ROMA. 1766*. Both vases were in the Marigny bequest to the Louvre in 1885. They are currently on loan to the Musée des Arts Décoratifs, Paris. The dimensions of the second vase are 39 × 18.2 cm. It is signed on the lip: *CLODION IN ROMA*. While the division of the body and the narrative space of the second vase is similar to that of the Chicago vase, its lower register is decorated with a pattern of acanthus leaves rather than gadrooning, and the handles are formed of intertwined snakes. These latter characteristics are found in the vase engraved by Petitot (note 20).
There is a drawing in Berlin that was catalogued as an autograph sketch by Clodion for the Louvre terracotta vases. See Ekhart Berckenhagen, *Die Französischen Zeichnungen der Kunstbibliothek Berlin*, Staatliche Museen, Preussischer Kulturbesitz (Berlin, 1970), pp. 362–63, no. 3865.
Careful examination of the drawing, however, indicates that it was made after the vases. For example, in the profile of both vases the figures are shown to be in low relief, carefully recording the

three-dimensionality of the subject. The drawing comes from the famous French nineteenth-century collection of Hippolyte Destailleur. While it seems to record the Louvre vases, there is the remote possibility that it records a pair of marble vases instead.

36. The vases were sold from the collection of Mariette, Paris, Nov. 15, 1775, pp. 11–12, cat. no. 61. On Apr. 8, 1777, they were sold in Paris from the collection of the Prince de Conti, p. 319, no. 1270. On Feb. 22–24, 1897, they were sold in Paris out of the Goncourt collection, p. 30, no. 236.

37. For a discussion of the Medici and Borghese vases and their locations and importance to artists during the seventeenth century and later, see Haskell and Penny (note 8), pp. 314–16, nos. 81–82.

38. On Poussin see Fort Worth, Kimball Art Museum, *Poussin: The Early Years in Rome*, exh. cat. by Konrad Oberhuber (1988), pp. 179, 276, nos. 56, 57. Oberhuber points out that these early paintings by Poussin are based closely on Roman sarcophagi reliefs and that they are also related to paintings of putti by Titian.

39. There is ample evidence of the popularity of Duquesnoy's sculptures in eighteenth-century France. They often appear in the sale catalogues of important private collections such as that of Mariette, in which ten terracotta sculptures by Duquesnoy (called François Flamand) are listed (pp. 8–9, nos. 30–39). Reliefs by or after Duquesnoy often appear in French still-life paintings as well. See, for example, Chardin's trompe-l'oeil painting after a bronze of Duquesnoy's *Eight Children Playing with a Goat* in The Cleveland Museum of Art, *Chardin*, exh. cat. by Pierre Rosenberg (1979), pp. 154–56, no. 33, or Desportes's *Still Life with Bronze Bas-Relief* in Michel and Fabrice Faré, *La Vie silencieuse en France: La Nature Morte au XVIIIᵉ siècle* (Fribourg, 1976), p. 92, fig. 142, in which the same composition by Duquesnoy appears. It is interesting to note that Clodion repeated on one of the Boston vases the detail of the putti cutting a tree branch from the left of Duquesnoy's relief.

40. A still-life painting by Jean Louis Prévost (see Faré [note 39], p. 294, fig. 477), which is undated but was probably executed in the 1780s, shows the same vase model in terracotta as that seen in Boucher's painting of 1763. The pendant still-life by Prévost (see Faré [note 39], p. 294, fig. 476) shows a different terracotta vase decorated with playing putti, the model for which is also by Clodion. This second vase model reappears in gilt bronze in another still life by Prévost which is signed and dated 1790 (see Faré [note 39], p. 291, fig. 470). The presence of these vases in dated paintings of the late eighteenth century gives us a terminus ante quem for the vases themselves.

41. A tinted plaster vase owned by Dalva Brothers, Inc., New York, and paired with the terracotta vase discussed above (fig. 4), has the same relief decoration of playing putti as a marble vase in the James A. de Rothschild Collection at Waddesdon Manor. See Terence Hodgkinson, *Sculpture: The James A. de Rothschild Collection at Waddesdon Manor* (London, 1970), pp. 22–23, no. 4. While the reliefs on these two vases are identical, the shapes of the vases are not. The Dalva vase has the same shape as its mate, with a fluted neck and foot and swags of laurel leaves suspended from two horned masks. In the Archives at the Manufacture Nationale de la Céramique at Sèvres, this shape is referred to as "Vase Clodion B," indicating that Clodion provided the model for Sèvres. In contrast, the Waddesdon vase is ovoid, with a pedestal foot that is closer in shape to that of the Chicago vase. To further complicate

the matter, the gilt-bronze vases in a private collection in New York are of the same shape as the Waddesdon marble vase and have the identical relief decorations on both vases of the pair.

The mate to the marble vase at Waddesdon (Hodgkinson, pp. 20–22, no. 3) is decorated with a relief of playing putti that is identical to the relief with playing putti found on the terracotta in the Prévost still-life painting (Faré [note 39], p. 294, fig. 476) and that is repeated again on a pair of bronze vases in the Ashmolean Museum, Oxford (fig. 19).

I have given this admittedly confusing list of variants of these vases to indicate the popularity of the models, the difficulty of their dating, and the probability that many of them are not by Clodion himself, but by other artists imitating his models.

42. A. Dingé (note 2), p. 1: "L'admiration que lui inspiraient les précieux restes de l'antiquité grecque et romaine, ne lui fermait point les yeux sur ce que les modernes ont fait de beau; et, tout en étudiant les maîtres, il cherchait, comme eux, la vérité et la beauté dans la nature."

Brown, "The Return of the Salon: Jean Léon Gérôme in the Art Institute," pp. 155–73.

I have received much help in this work and would like to thank Joseph Berton, Helen Chillman, Rachel Dressler, Gloria Groom, Maureen Lasko, Ian Wardropper, and Faye Wrubel for their generous assistance.

1. On American collectors and collecting in Paris in this period, see Albert Boime, "America's purchasing power and the evolution of European art in the late nineteenth century," in *Saloni, gallerie, musei e loro influenza sullo sviluppo dell'arte dei secoli XIX e XX* (Bologna, 1981), pp. 123–40. Two interesting first-hand documents of American collecting in which Gérôme figures prominently are Madeleine Fidell Beaufort, Herbert L. Kleinfield, and Jeanne K. Welcher, eds. *The Diaries 1871–1882 of Samuel P. Avery, Art Dealer* (New York, 1979); and *The Diary of George A. Lucas: An American Art Agent in Paris, 1857–1909*, transcribed and with an intro. by Lillian M.C. Randall (Princeton, 1979).

2. H. Barbara Weinberg, *The American Pupils of Jean-Léon Gérôme* (Fort Worth, 1984), pp. 35–47.

3. John Shirley-Fox, *An Art Student's Reminiscences of Paris in the Eighties* (London, 1909); John C. Van Dyke, *Modern French Masters* (New York, 1896); and "American Artists on Gérôme," *Century Magazine* (1889), pp. 634–36, including letters from E. H. Blashfield, George deForest Brush, Kenyon Cox, Wyatt Eaton, Will H. Low, John H. Niemeyer, A. H. Thayer, S. W. Van Schaick, and J. Alden Weir.

4. The Art Institute acquired the painting from Hans Calmann, London. It has been featured in the following exhibitions: Dayton, Ohio, The Dayton Art Institute, *Jean-Léon Gérôme*, exh. cat. by Gerald M. Ackerman with essay by Richard Ettinghausen (1972), pp. 32–33, no. 2; and Japan, Gifu, *Paris autour de 1882*, 1982, no. 21. The major bibliographical references include: John Maxon, *Paintings in The Art Institute of Chicago* (Chicago, 1970), p. 264; Gerald M. Ackerman, *Life and Works of Jean-Léon Gérôme* (London, 1986), p. 190, no. 38; and Richard R. Brettell, *French Salon Artists 1800–1900, The Art Institute of Chicago* (Chicago, 1987), pp. 28–29.

5. Charles Moreau-Vauthier, *Gérôme peintre et sculpteur* (Paris, 1906), pp. 160–62. The cause of this duel is obscure; Ackerman (note 4), p. 59, citing contemporary sources, suggested that rivalry over a woman may have been involved. It occurred shortly before Gérôme was to leave on a painting trip to Egypt; he went with his arm in a sling.

6. Marie Madeleine Aubrun, *Henri Lehmann 1814–1882, catalogue raisonné de l'oeuvre* (Paris, 1984), no. 257.

7. Robert L. Herbert, "Courbet's *Mère Grégoire* and Béranger," *The Art Institute of Chicago Museum Studies* 13, 1 (1987), pp. 25–35.

8. Eugene Benson, "Jean Léon Gérôme," *The Galaxy* 1 (Aug. 1866), p. 582.

9. One of Gérôme's artistic tours of Egypt and the east is described by a companion, Paul Lenoir, in *Le Fayoum, le Sinaï, et Petra* (Paris, 1872).

10. For this aspect of Gérôme's art, which is not represented in the Art Institute, see Richard Ettinghausen, "Jean-Léon Gérôme as a Painter of Near Eastern Life" in *Jean-Léon Gérôme* (note 4), pp. 16–26. Also see Linda Nochlin, "The Imaginary Orient," *Art in America* 71 (May 1983), pp. 118–31, 187–91.

11. Quoted in Georges Jeanniot, "Souvenirs sur Degas," *Revue universelle* (1933), p. 172; the painting is illustrated in Ackerman (note 4), p. 59.

12. The painting was subsequently sold at auction (American Art Association, New York, Mar. 24, 1887), after which it was owned by E. H. Van Ingen, New York, followed by the George F. Harding Museum, Chicago. The painting was exhibited in New York at the "Centennial Exhibition," 1876, and in 1972 in Dayton, Ohio: see *Jean-Léon Gérôme* (note 4), p. 73, no. 27. It is discussed in Fanny Hering, *Gérôme* (New York, 1892), p. 236; Henry James, *Parisian Sketches* (New York, 1957), pp. 98–99; *The Emma Holt Bequest: Sudley, Illustrated Catalogue and History of the House* (Liverpool, 1971), p. 31; William R. Johnson, "Gérôme an archaeologist?," *Bulletin of the Walters Art Gallery* 25, 7 (Apr. 1973), n.p.; Liverpool, Walker Art Gallery, *Foreign Catalogue* (Liverpool, 1977), no. 230; Ackerman (note 4), p. 238, no. 248; and Brettell (note 4), pp. 98–101.

13. For Stewart as a collector, see Boime (note 1); for a more contemporary view, see *Artistic Houses* (New York, 1883), pp. 7–18. Stewart gave heavily to charity, notably to famine relief in Paris during the Franco-Prussian War and $50,000 to relief in Chicago after the Great Chicago Fire of 1871.

14. Both the Havemeyers and Mrs. Palmer focused on works of the Impressionists, although their tastes evolved over time and their collections included many more academic artists. For a detailed discussion of this shift in taste, see Frances Weitzenhoffer, *The Havemeyers, Impressionism Comes to America* (New York, 1986). On Mrs. Palmer, see Richard R. Brettell, "Monet's Haystacks Reconsidered," in *The Art Institute of Chicago Museum Studies* 11, 1 (1984), pp. 15–21.

15. James (note 12).

16. *Catalogue of the A. T. Stewart Collection* (New York, 1887), pp. 58–59. The three Gérômes in the Stewart sale sold well: *The Chariot Race* for $7,100; *Pollice Verso*, today in the Phoenix Art

Museum, for $11,000; and *A Collaboration*, now lost, for $8,100. These were some of the best prices realized, but the collection as a whole suffered because it was seen as reflecting an outdated taste.

17. Ackerman (note 4), p. 108, nn. 294–95. Françoise Forster-Hahn, "Marey, Muybridge, and Meissonier, The Study of Movement in Science and Art," in *Eadweard Muybridge, The Stanford Years, 1872–1882* (Stanford, 1973), pp. 85–109 passim. The comment on Gérôme's anatomical error also appears in *Artistic Houses* (note 13), p. 74.

18. Johnson (note 12), n.p.

19. Israel Pemberton, "Pollice Verso," *The Librarian* (1879), pp. 4–6. This painting was also in the Stewart collection (see note 13).

20. The engraving mentioned by Gérôme in his letter describing *The Chariot Race* (see p. 164) was by the sixteenth-century painter and printmaker Maerten van Heemskerck and portrayed the Septizonium as a three-story building. It is clear that it was the name of the edifice, rather than the engraved view, that determined Gérôme's reconstruction.

21. James (note 12), p. 98. Another painting Gérôme set in the Circus Maximus is *The Christian Martyrs* (Baltimore, Walters Art Gallery), a work that was in the artist's studio with the Art Institute picture for over a decade. *The Chariot Race* was ordered in 1860; however, due to the artist's painstaking approach, it was not delivered until 1883.

22. The other drawing is reproduced in *Gérôme* (Vesoul, 1981), no. 77.

23. Ackerman, "Gérôme and Manet," *Gazette des Beaux-Arts* 70 (1967), pp. 163–76; Washington, D. C., National Gallery of Art, *Manet and Modern Paris*, exh. cat. by Theodore Reff (1982), pp. 212–21.

24. *Qui que tu sois, voici ton maître! Il l'est, il fut, ou le doit être!* The Art Institute received the painting from the George F. Harding Museum, Chicago. It was exhibited in the Salon of 1889, no. 1152. Publications in which it is discussed include: *Le Figaro*, Apr. 30, 1889; Albert Wolff, *Figaro-Salon* (Paris, 1889), n.p.; Georges Lafenestre, *Le Livre d'or du Salon de peinture et de sculpture* (Paris, 1889), pp. 42–43; Hering (note 12), p. 272, pl. between pp. 184–85; and Ackerman (note 4), p. 262, no. 361.

25. Voltaire, *Contes, poésies mêlées*, XI, in *Oeuvres de Voltaire*, vol. 1 (Paris, 1838), p. 66.

26. *Familiar Quotations*, 15th ed. (Boston, 1980), p. 344; George Brandes, *Voltaire*, vol. 1 (New York, 1930), pp. 325–26; Voltaire (note 25).

27. Hering (note 12), pp. 272–73; Honoré de Balzac, *Père Goriot* (New York, 1956), p. 5.

28. For Voltaire and the *Greek Anthology*, see James Hutton, *The Greek Anthology in France and the Latin Writers of the Netherlands to the year 1850* (Ithaca, N. Y., 1946), pp. 539–46.

29. "Et nous voici devant le tableau de M. Gérôme, de *L'Amour vainquer des fauves*. Nous nageons ici en pleine fantaisie, car dans la réalité les lions et les tigres se jetteraient sur ce bambin aux chairs fraîches et n'en feraient qu'une bouchée. Mais je ne suis pas de ceux qui veulent emprisonner l'art tout entier dans une même formule; je comprends parfaitement que les scènes de pure imag-

ination ont leur raison d'être, pourvue que l'artiste y déploie, comme M. Gérôme, le meilleur de sa science et de son talent particulier."

30. Reproduced in Ackerman (note 4), p. 256, no. 333. For Cupid in a domestic contemporary setting, also see *The Love Letter* (1889, lost), reproduced in Ackerman (note 4), p. 262, no. 357.

31. The curious stool on which Gérôme sits in the photograph is a Middle Eastern bird cage, no doubt a travel souvenir, such as the one shown in his painting *Bashi-Bazouk Singing* (Baltimore, Walters Art Gallery). Behind the canvas, we can see other studio paraphernalia against the wall and, in the far room, casts or reproductions of ancient armor which can be recognized in other works.

32. Moreau-Vauthier (note 5), p. 263.

33. The sculpture's base is signed on left side: *J. L. Gérôme*; right side: *F.BARBEDIENNE FONDEUR, PARIS* (founder); and back: *REDUCTION MECHANIQUE, A.COLLAS BREVETE*. The original plaster was exhibited in the Salon of 1881, no. 3924. This cast was exhibited at the Los Angeles County Museum of Art, *The Romantics to Rodin*, exh. cat. (1980–81), pp. 286–87, no. 152. Major publications include: J. Buisson, "Le Salon de 1881," *Gazette des Beaux-Arts*, 2d ser., 24 (1881), pp. 214–16; *L'Exposition des Beaux-Arts* (Paris, 1881), p. 302; *Le Livre d'or du Salon de peinture et de sculpture* (Paris, 1881) n.p. (size given as 190 cm); *Gérôme* (note 22), p. 145, no. 181; Ackerman (note 4), p. 312, no. S10.

34. See Paris, Bibliothèque Nationale, *Catalogue général des livres imprimés*, vol. 2, cols. 1108–25; see also Hutton (note 28).

35. Ackerman (note 4), p. 312, no. S10. There seems to be some confusion in the literature regarding sizes. There is also a large marble version (h. 189 cm.) in Copenhagen at the Ny Carlsberg Glyptothek.

36. The sculpture was a bequest from the Chicago collector Arthur Rubloff. Exhibitions: Salon of 1897, no. 2987. Major publications include: Gaston Schefer, *Goupil's Paris Salon of 1897* (Paris, 1897), pp. 58–59; and Ackerman (note 4), p. 322, no. 538.

37. Ackerman (note 4), p. 150, no. 378.

38. Ibid., nos. 171–74, 466, 539, 558.

39. I am indebted to Joseph Berton for information about the Egyptian campaign and militaria. See Ackerman (note 4), p. 322, no. 539.

40. Ackerman (note 4), p. 280, no. 441. Gérôme also exhibited at the 1897 Salon a life-sized bust of Napoleon.

41. As quoted in Gustave Haller, *Nos grands peintres* (Paris, 1899), pp. 154–56. This book was published by Boussod, Manzi, Joyant, successors to Gérôme's father-in-law, Goupil.

42. Benson (note 8), p. 587.

43. Ottawa, The National Gallery of Canada, *The Other Nineteenth Century: Paintings and Sculpture in the Collection of Mr. and Mrs. Joseph M. Tannenbaum*, exh. cat. by Louise d'Argencourt and Douglas Druick (Ottawa, 1978). This was one of the first wide-scale reconsiderations of French official and academic art in the period 1850–1900.